# LAUGHING EYES

# Preface

"You who are on the road must have a code that you can live by...."

What a journey this life is and what a fantastic voyage of self-discovery. We are propelled along this lifeline by the advice of trusted parents, family and friends and the quality of that advice and how closely we listen to it determines how we reach the end of the line. Reading the letters between Edward Weston and "Laughing Eyes," brings one closer to understanding the relationship between father and sons. Regardless of the personal diversions that Edward took in his life, it is very obvious that he held a deep and abiding love for his children.

"Teach your children well, their father's hell did slowly go by..."

I greatly admired the courage with which Edward chose to live his life. As an artist myself, I know firsthand the delicate boundaries and balances between the 'inside' and the 'outside', between what feeds my artistic soul and what stifles it. Edward was smart enough to recognize that if he couldn't be true to himself and his art then what good would he be as a person or as a father. How lucky these children were to be able to look back and realize what a treasure these letters were and what a wonderful legacy they would ultimately prove to be. This 'peep-hole' into the lives of America's First Family of Photography reminds me of my relationship with my father, the man who started me on my own personal journey into the Arts by introducing me to the magic of photography at the tender age of ten. Although life is far from perfect, the lives led by the Westons were full of warmth and contact between disparate souls.

"So just look at them and sigh, and know they love you".*

> — Graham Nash
> Hawaii
> August 9, 1999

*"Teach Your Children" written by Graham Nash, published by Nashnotes, BMI inc.

# LAUGHING EYES

A Book of Letters Between Edward and Cole Weston

## 1923-1946

Compiled and Edited by Paulette Weston

Preface by Graham Nash

Carmel Publishing Company, Carmel California

Carmel Publishing Company
P.O. Box 2463
Carmel, CA 93921

Cataloguing-in-Publication Data
Library of Congress Card Catalogue Number: 99-067413

Weston, Paulette Laughing Eyes,
A Book of Letters Between Edward and Cole Weston / Paulette Weston
p. cm. ISBN 1-886312-09-5

Edward Weston photographs used with permission of the Center for Creative Photography,
Arizona Board of Regents
© Center for Creative Photography, Arizona Board of Regents

First Edition

Printed and bound in China

10 9 8 7 6 5 4 3 2 1

To my teacher, my lover, my husband,
Cole Weston.

# Contents

# Foreword

The publication of these letters provides an intimate and fascinating glimpse into the lives of the First Family of twentieth-century American photography — the Westons. A member of the Weston family has been actively photographing since 1911, when Edward Weston began his professional career in suburban Los Angeles. Two of his four sons have had renowned careers in photography spanning the last three-quarters of this century. Edward's second son, Brett, photographed from the late 1920s until his death in 1993; and his youngest son, Cole, who started making photographs around 1932, is now one of this country's most recognized color photographers. The way things are currently going with Cole's son, Kim, there is every likelihood we will still have a Weston photographing well into the twenty-first century.

Whenever life separated father and son — as happened often between 1923 and 1946 — Edward Weston and his son Cole maintained a correspondence that ran from the newsy to the philosophical. Their letters provide a parallel picture of an artist maturing into his role as one of the great photographers of this century and of a boy growing up through the era of the Great Depression and World War II. We are given a privileged vantage point from which to watch the most important years unfold in the life of Edward Weston. We see Edward as father, lover, husband and artist. Some of the key friends and fellow artists also cross the stage briefly: Tina Modotti, Ansel Adams, Peter Stackpole and Edward Steichen.

But just as vividly, we witness the youth and emergence of the next generation of Westons — Chandler, Brett, Neil and most clearly, Cole. Cole's first letter, written in early

1924, a few months after his father and Tina Modotti had moved to Mexico, is a heart-rending four words long: "Dear Daddy, Come home." When the correspondence between father and son ends in 1946, Cole had been discharged from the Navy and was about to give up a short-lived attempt to fit in as a photographer for Life magazine. As he prepared to return to California to become his father's assistant, he wrote, "After looking at the ten prints of the sand dunes you showed me, I decided that I knew nothing about photography and that it was about time that I learned if I was planning to continue called myself a pho-tographer."

These letters have been edited with great adeptness by Cole's wife, Paulette Weston, who uses succinct introductions and letters to and from other friends and family members, to round out the narrative and fill in the inevitable gaps in correspondence between Edward and Cole.

> — Terence Pitts
> Director
> Center for Creative Photography
> Tuscon, Arizona
> June, 1999

# Introduction

I was an archaeologist with a passion for photography when I first met Cole Weston at a workshop he was teaching in North Carolina in 1986. I had been reading books about his father Edward and wanted to learn Edward's simple photographic techniques and hear the stories of this remarkable family.

I spent the next two years photographing, working in the darkroom and learning. Then in 1988 I was off to another Cole Weston Workshop, this time in Hawaii. During the day I attended dark room sessions at Brett Weston's home on the Big Island and photographed extensively, working for the first time with a nude model. Evenings were spent talking with Cole and his brothers Brett and Neil. Before the workshop was over, Cole asked me to come to Carmel for six months to be his assistant while he printed his first portfolio. I have been here ever since. Cole and I were married August 3, 1991.

From the moment I moved to Carmel I was immersed in the Weston legacy. Cole's home is filled with Edward's memorabilia, pieces of art and of course, photography by both of them. The desk where Edward wrote the "Daybooks" was next to my bed.

Being Cole's assistant meant not only working with his color images, but also with Edward's images printed by Cole. This is how I was introduced to the vault, a treasure trove of Weston fine art photographs, family photos and letters. In the process of organizing the vault so Cole and I would be able to find things he wanted to sell or keep in the family I ran across a box of letters. I asked Cole if he knew they were there and he said, "No."

The Center for Creative Photography from Tucson, Arizona had gone through Cole's

vault several years earlier and picked out things they wanted to buy for their archives. They took all the letters from the other boys, but left Cole's and his father's because they were Cole's property. Edward had stopped writing his "Daybooks" in 1934, but this correspondence between Cole and his father continues until 1946. It was then that I realized I had found the continuation of the "Daybooks."

Recognizing the historic value of these letters and family photographs I decided I would do something with them. I waited several years until Cole's seventy-ninth birthday. Everyone kept telling me, "Wait until his eightieth," but you never can tell what will happen. First I called the Center for Creative Photography to see if they had any letters from Cole to his father, letters that may have been in with the letters to the other brothers. They sent a couple of Cole's earlier letters, written to Edward in Mexico, ones he didn't know about that included his childhood drawings.

Then I went to the vault and collected letters, photographs and notes and compiled them into a manuscript. Months were spent transcribing the letters and scanning in the photographs. Edward and Cole each have their own letter writing style. To retain the personal character of the correspondence I did not edit for spelling or punctuation. Any interjections for clarity I have made are in brackets, or brief comments in italics.

It was a five month project. The computer went down and I lost everything; the first one hundred ninety-six pages of the manuscript, all the photographs, everything. The last month I was working eighteen to twenty hours a day because I wanted to complete "Laughing Eyes" for Cole's birthday, January 30th. Many tears were shed, but I finished it in time.

Cole kept saying, "What are you doing?" and "You're killing yourself." and "Stop." Stubbornly I said, "No, I am going to finish this." So, to surprise this man who doesn't get many surprises, I decided I would have a nude jumping out of a box bring him this book. Now, several friends were in on this, but Cole knew nothing about it. A very dear friend who does nude modeling for photographers agreed to jump out of the box. We sent Cole into a bedroom, the girl got in the box. Cole came back into the living room and sat down. He said, "Well, where is my present? I want it now." And I said, "Darling, you know, you're always telling me to stop spending so much time upstairs, (where the computer is) that I thought you would like a computer of your own." As I said the word, "computer" the young lady jumped out of the box. Cole's mouth dropped open. The nude ran over to him, straddled his lap, gave him a big kiss and handed him the book. I had forgotten to warn a couple of friends who had brought their teenage daughters. I learned later the girls put their hands over their eyes and wouldn't look.

Now, Cole remembers the nude very well, but sometimes forgets she had my book in

her hands. But who could blame him? The day after his birthday he sat down to read the letters. Forgotten memories came back and there were tears in his eyes.

For his eightieth, I put together a historic show of photographs by seven Westons. I reserved all the gallery space at the Pacific Grove Art Center, located on the Monterey Peninsula. Over two hundred photographs representing the work of Edward, his four sons, his grandson Kim and myself were over matted and framed. Two of Edward's sons are well known photographers, Brett, as a master of black and white, Cole, a master color photographer. The oldest son, Chandler, tried for awhile to make a business out of portraits, but he was more the inventor. Edward's third son Neil, took some snaps as they were called, but he was a boat builder and carpenter; he loved to work with his hands. When he was in his late seventies, Neil decided to become a color photographer. So he came to the house and said, "Cole, I want you to teach me."

"Okay," Cole said. He started by giving Neil the equipment to process 8 x 10 color prints. Cole said, "Neil, if you like this, I'll teach you to use the Cap 40," which is a processing machine for 16 x 20 prints. Neil said, "Great." We went over to Neil's house and Cole gave him a lesson. About two days later, Neil called and told Cole the technique he had been using for decades was totally wrong. Cole laughed and said, "Neil is the expert now. I've only been working with color since 1947. This is typical of older brothers."

What wasn't typical during Cole's childhood was the fact he and his brothers frequently moved back and forth between their mother and father's homes. Divorce was not common in the1920s and 30s. Even in this disjointed atmosphere the letters are intact, due to Edward's habit as a saver. I found letters, photographs and notes that were handed down to Edward from his father, some dating back to 1832. In turn, Edward kept all the letters his sons had written to him. Now Cole is the saver of the family. After Edward's death on January 1,1958 Brett divided all the original prints between the four boys, but the other brothers were not interested in old letters or family photos. Thank God Cole saved them.

Before I began "Laughing Eyes" I read all the letters. Some of them made me cry. I didn't live through the Depression. To read how Edward felt with four sons in World War II and how he was trying to protect the Japanese people on the Monterey Peninsula is like watching a movie. At one point he says he would rather go to the front and take some young man's place because he had all of his life experiences. One of the recurring themes through this correspondence is that each son should make his decisions, have his life experiences and do what he feels he needs to instead of what someone else pushes him into. When Cole read these war time letters, sitting in bed, I watched tears form and roll down his cheeks.

Cole does a slide show and lecture called "Edward Weston, The Man Not the Myth." The love Edward had for his sons isn't really brought out in that show, it should be. I've read all the sons' letters now and it is obvious that the love between the father and each boy was different. Brett is more of a companion, a fellow photographer. Letters to Neil are full of news of Edward's daily life. Cole is told the secrets. For Chandler, we only have letters that were written in Mexico because he excommunicated himself from the family in later years. He wanted to prove to the world that his mother and father gave him a terrible childhood. He was at odds with both of them.

I was at a gathering at Brett's house once in the late 1980s, when all four boys were still alive. They were sitting together on the couch. Chandler started talking about their mother and his terrible childhood. Brett asked him to leave. The children knew they weren't growing up like other children, but they loved both parents. Besides, they had some great experiences and the world got two giants of photography out of four sons. So I think both parents did a good job of raising them. They gave them the love.

I would hope people interested in photographic history will see that "Laughing Eyes" is a continuation of Edward's "Daybooks" and that it also depicts a portion of Cole's life that hasn't been written about; his life with Dorothy and his desire to be a photographer. At the same time I hope mainstream people like my own mom and dad in the South, when they read it, will see a love and trust between a father and a son.

In my own family I hope the letters I send to my grandson are saved, I'm saving all of his. I think one of the problems of today is we've gotten away from writing. Since we don't write, we lose track of people, our family, friends, whoever. Our e-mail is erased but letters are saved. We as a society should write letters and tell our feelings and then have the other person save them. I've saved all of my letters from my sisters and family, not that they'll ever be in a book, but they're something that I can look back on and say, "I remember that time and it was a good time for me."

It was the same way with Neil when he read his letters. In 1998 he was dying from pancreatic cancer and had a short time to live. I took his letters and transcribed them and added family photographs. I did it in only four weeks because we were going to Hawaii to visit him and I wanted him to have the book. I called it "Beloved Grey Boy," an endearment taken from Edward's letters. He cried when he saw it because he didn't remember the letters and didn't know they had been saved. He had forgotten the drawings he sent to Edward in Mexico. But again, Edward had saved everything. During the War, Neil was in the Merchant Marines, stationed in the South Pacific. He could not join the Armed Forces because of his migraine headaches. He writes about how he charged fifty cents or several bottles of beer for a haircut. As the only barber on board he always had a good supply of

beer. These memories brought back good times for him.

Originally I made three copies of "Laughing Eyes." One went to the Center For Creative Photography because they had sent me the early letters and because most of Edward's archives are there. I kept a copy and I gave one to Cole. Because of computer problems, I have lost most of the original manuscript. I can never replace what I've done. It was too many hours and too many photographs to scan.

Last year I loaned the "Laughing Eyes" manuscript to a neighboring photographer, Bob Kolbrener and his wife Sharon to read. It was at their house by pure chance that Barbara March discovered the letters and proposed to me that her company publish it as a book. Many books and articles have been written by and about Edward Weston, but this one shows us another side — the love and respect he had for his son Cole.

<div align="right">

— Paulette Weston
Garrapata Canyon
July, 1999

</div>

# Weston Family History

## 1886

Edward Weston entered the ancestral milieu of New England church men, educators and doctors when he was born March 24, in Highland Park, Illinois, the son of a doctor. The independent spirit Edward became known for can be traced first to his paternal grandfather, who left two hundred years of Weston history in Maine for Illinois and in the next generation to both his father, Edward Burbank Weston, who had the disparate hobbies of archery and poultry breeding and his mother, Alice Jeanette Brett Weston, a former Shakespearean actress.

According to Nancy Newhall's introduction in the "Daybooks," Edward remembered his father as a small, grey-haired stalwart man, somewhat remote but very kind. Memories of his mother, who died when Edward was five, were only of "a pair of burning eyes, perhaps they were burning with fever." His sister, May also known as Mazie, nine years his elder, raised him.

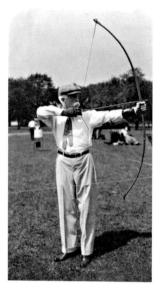

*Edward Burbank Weston*

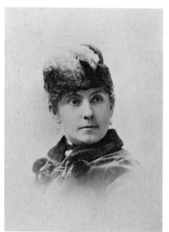

*Cole's grandmother,*
*Alice Jeanette Brett Weston*

## 1902

Edward's father's remarriage set up a familiar scenario. The elder Weston's new wife and teenage son brought a tension to the family and Edward and May were relegated to the top floor of the Weston home. Brother and sister were bound together by the loss of their mother. After marrying and moving to California, May corresponded with Edward daily.

According to Newhall, Edward was "bored at school, except at painting class and athletic events," and "made himself into a track star and took boxing lessons." His intellectual and creative interest was sparked and photographic history began when Edward was given his first camera, a Bull's Eye, by his father during a summer vacation on a

Michigan farm. He wrote, "Received camera in good shape. It's a dandy. I think I can work it all right. Took a snap at the chickens...."

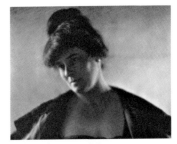

*Edward's sister, May*

1906

At age twenty Edward moved to Tropico, (Glendale) California to be with his sister, Mazie. First he took a job surveying for the railroads, but quit when he discovered the project was a hoax designed to sell real estate in the orange groves. Deciding to pursue his desire to be a professional photographer he wrote, "At least I would own the tools I needed." Buying an old postcard camera, he walked door-to-door selling portraits.

This same year Edward met Flora May Chandler. Daughter of Cornelius, a Chicago cabinet maker and builder and Ann Eliza, a rigid Victorian church woman, Flora was born on October 28, 1879. She caught Edward's eye when May introduced them at a garden party. Archery provided the setting. Flora was entering an archery contest, a sport Edward enjoyed with his father, when Edward saw her for the first time. As Flora drew her bow, aimed carefully and sent the arrow into the bull's eye, Edward said to himself, "There stands the future mother of my children."

*Flora*

*Edward*

*Edward and Flora's honeymoon, 1909*                    *Edward Weston*

1909

    After a three-year courtship Edward and Flora were married on January 30. Described by photographer Imogen Cunningham as much "like an electric fan you couldn't turn off," Flora was boisterous while Edward was quiet and observant. Edward would declare years later that he knew the morning after the wedding that he had made a terrible mistake. Yet throughout both their lives and despite Edward's numerous love affairs and subsequent re-marriage, the connection between Flora and Edward never wavered. Flora's belief in her photographer husband and her willingness to support him through his countless lean years speaks volumes for her devotion.

*Ann Eliza and Cornelius Chandler with their grandsons, Chandler and Brett Weston*

In spite of Flora and Edward's dissimilar temperaments, four sons are born to them over a nine-year period:

1910 - Edward Chandler
1911 - Theodore Brett
1916 - Laurence Neil
1919 - Cole

1911

Edward built a small portrait studio one mile from the family house in Glendale on a piece of land Flora inherited. The first week after he opened his studio, the total take was $1.00 for postcards, but soon he was successfully making portraits. He continued in his chosen profession until 1923, when yearning for a more creative life, he decided to go to Mexico.

*Chandler*

*Brett*

*Neil*

*Cole*

*One of Edward's first attempts at marketing.*
*The baby is his oldest son, Chandler.*

## THE XMAS
## PROBLEM

is always perplexing. What **shall** I give? Figure it out and you will agree there is no gift you could make for any where near the same money, giving so much pleasure to the recipient as a portrait of yourself.

A portrait by Weston has character, individuality and artistic taste. My aim is to have every patron say,"that is the best likeness I ever had."

Come visit my studio, just north of Tropico Avenue on Brand Blvd., and I am sure you will be satisfied that you need not search further. The standard of my work has been set to compete with that obtainable any where, at any price. Come early and avoid delays.

Read the little note on the other side. It will be worth your while.

## "CHILDREN ESPECIALLY."

*Tina, 1923*                                                    *Edward Weston*

# 1923 - 1927

Edward, with his lover and assistant Tina Modotti and his oldest son Chandler (Chan), leave Los Angeles for Mexico where Edward seeks to discover the great images he knows are in him. Yet as he begins his work, he misses his three other sons who remain behind with their mother, Flora. Edward's letters to Cole begin on September 6, 1923, when Cole is four years old and can neither read nor write.

Edward's letters are from a lonesome father, who consciously or not, is also communicating with his estranged wife. Cole always responds, through his mother, with drawings and the recurring theme: "Daddy, when are you coming home?" But Edward knows that coming home, as Cole asks, is not to be. In his daily journal, written at the same time as his letters, Edward confesses that although he wants to be near his children, there can be no reconciliation with Flora.

Cole remembers: "Mom would come home from teaching school, go out into the yard and water the flowers for hours. While she was watering, she would sing. I always thought she was singing because she was happy. Years later I learned she was singing because she was sad."

For Cole's sake, Edward does come back at the end of 1924. While Tina remains in Mexico to continue her own photographic work, Edward moves into his old Glendale studio. While Edward lives in the studio, the boys, including Cole, are his constant companions; but Edward is restless and wishes that he had remained in Mexico. Instead, taking Neil with him, he goes to San Francisco where he shares a studio with photographer-friend Johan Hagemeyer. The two have a joint exhibit at Gumps, a department store specializing in fine art goods. Edward continues doing portraits, not earning much money. Neil returns to Los Angeles and Edward stays on in San Francisco.

Broke but knowing he now has to return to Mexico, Edward goes back to Los

Angeles in July of 1925 where he has an exhibition at the Japanese Club and sells $140 worth of prints. The next month, on August 21, Edward sails for Mexico, this time with his son Brett. He continues to support himself in Mexico with portrait work and in April, 1926 — nearly a year after leaving the rest of his family in Los Angeles — Edward accepts a commission to make photographs of Mexican popular art for the book "Idols Behind Altars" by Anita Brenner. There are only a few letters between Edward and Cole during this period. Even in his daily journal Edward rarely mentions his children.

In November, 1926 Edward makes his final farewell to Mexico and Tina Modotti. Taking Brett with him he again returns to California and his Glendale studio. By the end of the year he has collected four cats and declares to all that he and Flora are separated. The boys continue to stay with their father whenever possible and Edward nurses Cole, now seven, after he fractures both wrists in a fall from a tree. Simultaneously preparing for a major show, filling a large order and caring for Cole takes its toll on Edward. He describes this time as the most difficult period of his life. Cole remembers wearing bib overalls, his arms crossed inside the bib, to the opening of his father's one man show at the Los Angeles Museum.

"As I walked around the show, people put nickels in my bib."

*Neil, Flora, Cole and Brett saying farewell to*
*Edward and Chandler, 1923*

*Edward Weston*

September 6, 1923

Cole! - you rascal - you rogue with laughing eyes! You are right here in my arms now or on my shoulders - while I go prancing around the room like mad - right here I tell you! - and then I get a queer feeling when I awaken and wonder if the next time I see you - you'll be too big a boy to ride on daddy's shoulders - You know one book I brought with me was the "Child's Garden of Verses" - the old copy which I've read to each of you boys in turn - I like to read it now and do a lot of pretending and dreaming! - well I'm getting suspiciously sentimental - and you - not yet having tasted this unfortunate plight - will not know what I mean - I just wrote Neil about the pigs and cows - what do you think - little Indian boys not so big as you are taking care of them - drive them hither

*Chandler en route*    *Edward Weston*
*to Mexico, 1923*

and thither to fresh pasture all day long —I told Neil that I remembered a walk we had together at the same time I thought of a night you and I walked or rather ran in the pouring rain from the studio to home - you were on my back and Dad was almost breathless we went so fast -

Lllewllyn [Bixby-Smith, a pupil of Edward's] has a dandy dog - a police-dog - he's very mischievous though and chews up everything from lilies to toilet paper! - I don't let him get too friendly with me - I have enough trouble with fleas already. Just think Cole - how high up in the air we live - this city is almost half as high again as those big mountains you see to the north - Mt. San Antonio - Mt. Wilson - and because we are away up - the water boils at a lower temperature and fools us when we cook eggs - I have just had my lunch - two aguacates (the right word for avocado) bread and olive oil (instead of butter which is not used much here except in cooking) and a bottle of beer - the aguacates cost us about two for 15 cents and are so good - the olive oil comes from Italy and is cheaper and better than the American - the beer called "Cervesa" here - is delicious too - and one can drink it without fear of death - it costs about 14 cents U.S. a bottle.

Kiss your mother for me - be good to her - keep your nose clean and your pants dry - and listen to the little pine trees whisper in the evening breeze - they'll tell you a secret - "I love you" —

Daddy

March 2, 1924

Babykins Cole —

Six months since I have seen you!  Do you even remember how I look?  I wonder because my mother died when I was five and all that returns to me of her - are a pair of black piercing eyes - burning eyes - maybe burning with fever - but Mr. 'Gehee says you are the image of me - so all you have to do is look in the mirror and see Daddy and yourself all in one!  Say Master Mischief - my greatest desire is for ten minutes romp at "hide and go seek" with you - to hear your shrieks of joy and to see your eyes snap and sparkle - or to have you jump from the terrific heights of some table - jump with a shiver across the yawning chasm into the sure safety of my arms - so let's plan this prodigious exploit - you and I! - anticipation is good tonic for the blues - we'll plan hard - shall we?

xxxxxxxxoooooooxxxxxxooooxxxxxoooxxx

May, 1924

Dear little Boys —

Today I went into an old book shop and found the charming pictures I am sending you - they only cost a few centavos but are old and rare - they go to you with much love - tell Brett the next package will be for him - if he would like some pictures like yours - tell him to write me at once —

Always love and hugs

Daddy

June 10, 1924

Hello Master Sugar Plum!

Return to me?  Yo te amo!  Write me?  "Daddy"

"Como? Senorita" I said - prepared to bargain over a bouquet of mosquetas seductively fresh and fragrant - "quince centavos senor - muy fresca - muy barata" - yes they were cheap - I was ashamed to bargain and took them with no further palavar - it was the market of San Juan - I had gone hoping to find some little things for the children and I found mostly food and flowers - the flower market lined both sides of the street for a block - to walk there is to be transported into a fairy land - flowers might be had for any mood - all the old fashioned flowers of one's childhood - stocks - pinks - forget-me-nots - daisies - gladioli in

profusion and then stranger tropical bloom - gorgeous - aloof - unapproachable - at least to an Anglo Saxon - the display of fruit almost equaled that in la Merced - a mango de Manilla for cinco centavos completed my expenditures and I made haste for the bank and more sordid aspects - two months rent in advance is our contract with the new dueno - not easy to pay - for my recent sittings have not been profitable - prospects become less possible to reckon with - I only hope to stay long enough to work and create a comprehensive exhibit - then ? Well —

I ponder much over New York these days - it seems the logical place for my return - Rafael and Monna [Sala] are to write the Dunsening Gallery in New York about my work, sent a few prints and try to arrange an exhibit for the coming fall season. I should like to be there coincident - apprehend public opinion and make probable sittings - it is a shame to leave Mexico so soon - with so much yet to do and see - and with C [Chan] interested in his work as I have never known him before - at the head of his class he told me last night - but I cannot go on in this uncertainty - this pacing of floors and wondering what will happen next if I cannot work in peace here - I might better die fighting elsewhere for it is the instability of Mexico which is maddening - a land so rich - so beautiful - a race [the Indians] so tender - so lovable - and all smeared over with a slime but of political intrigue and treachery in which my own country has played its shameful part -

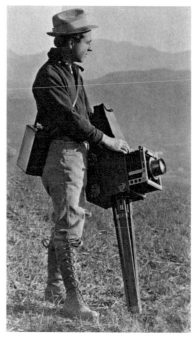

*Edward Weston*        *c 1924*

I walked to the Sala's [Rafael - a painter and his wife, Monna] last evening - through a stretch of open landscape on the way - the snowy summits of Ixtaccihuatl and Popocatepetl floated like clouds above a grey mist - detached from any earthly base - they rose into the heavens and in supernal majestic remained there for they are inhuman mountains - Ajusco was in the distance too - crowned with black clouds - he is a dark-gruff and mighty pile of rock - a friend of the wind - recipient of lightning - resounder of thunder - but he is of the earth - and human - very human -

August 10, 1924

Brett —

Neil —

Cole —

- the days pass with tolerable grace for I am ever busy with my work - but when night comes - then - how I do miss you!

To once more hold you in my lap - to read to you or talk to you - to hear your merry laughter - and I had hoped all this would happen soon again - but fate has decided no - not now - so all I can do is to walk the azotea - watch the great round moon and wonder if you are seeing it too —

Do you remember that little thumb-worn volume of "A Child's Garden of Verses" I used to read to you so often?  I have it here and in it have pasted all your pictures - the ones photographed from the boat leaving the dock - and the ones your mother sent me recently too - it is on my table where I write and I turn to it in lonesome moments - when twilight comes or with my morning coffee - it gives me pain and pleasure mixed - write me - tell me what you do - how big you are and many little things that I should like to know —

Chandler is a big boy now - you would notice it more than I - his voice has changed and he has grown heavier - he speaks Spanish almost as fast as English - he is very well - aside from a couple of colds has not had a sick day in Mexico - I give him "un peso" each week for car fare to school - from that he saves what he can - the next suit I buy him which must be soon - will be with long pants.

Now you owe me a letter - each one of you - business seems better than at any time since I've been in Mexico - though perhaps it is just because people thought I was leaving - if it keeps up and I get out of debt - I'll try to send you some money —

Love dear boys and to your mother —

Daddy - August 10, 1924

Ricardo Robelo [archaeologist and friend] died this week

*Also included with this drawing is this letter written by Flora for Cole:*

My dear Daddy —
When are you coming home?  I am not all better now.  I have a little bird x x    Mama is better now.  Uncle Neil will give her money someday.  Aunt Em gave me a quarter.  I have 5 cents in my bank.
          Love    Cole

October, 1924
Dear Babykins Cole —
          I don't suppose you really are a baby but I must still think of you that way - do your eyes still sparkle and snap and do you still have your freckles? - when I was a little boy they used to call me "Turkey Egg" because I had so many freckles!

I am writing once more from my exhibit - during quiet moments - and using scratch or waste paper of Chandler's - so I think these letters will not be beautiful - yesterday I sold my first print for which I got cash - though several have been promised - it was a picture of the Pyramid of the Sun and sold for 30 pesos to a man who has the best collection of my work down here - of course my greatest hope in showing is to get more sittings and I have prospects - well - two days have intervened since I started this letter - I was interrupted and then Sunday came and then happily I had a sitting this morning - I always feel better after a sitting which means money - nothing flourishes either art nor love nor peace on an empty pocket-book - it need not be so very full - just comfortable - I ask you Cole as I did Neil to write me and send me little pictures that you make - they keep me from getting too unbearably lonesome for you - and that is important like money if I am to work!

- and now this another new day!  It is taking me a long time to write your letter - I did not forget your mother's birthday - but had no chance to ship even a trinket - the newspaper clipping please give your mother - "a prophet is not without honor save in his own town" - perhaps someday they will erect a monument in my name in Glendale! - wouldn't that be funny! - quite too funny!

Just after this exhibit is to be an exhibit which both Tina and I are to enter in The School of Mines - under the government - awards are given and we hope for luck —
Yesterday came to the "show" one of Mexico's most important men Jose Vasconcelos -

Ministro de Educacion Publica - he wanted copies of seven prints for publication in his magazine - everyone comes in fact from poor poets to equally poor Marquesas - for the revolution has ruined royalty in Mexico.

Now dearest bright - eyes I'll say good-bye before another interruption! I send you so many hugs and so many kisses - this many!

xxxxxxxxxxxxxxxxxxxxxxxxxxxooooooooooooooooooooooooo plus!

Daddy

December, 1924

Bright Eyes! Mischievous One! Cole!

Last night I went to the "puestos" - they are booths filled with Xmas things which line the "Alameda" - our large and beautiful park - this time of the year - I came upon a Merry go Round - a Merry-go-Round is the saddest thing in the world - excepting lilacs in the rain - and an old waltz - I watched the Merry-go-Round for an hour - watched it's futile- whirling chase after some mocking joy - and I wished that I had several little boys to ride with on the horses and camels and giraffes - but I did not - so my sadness was intensified - and all I could do was to wish for you!

Are your eyes as bright as ever? Do you still do things which afterwards you find out were wrong - and tearfully wonder why? Silly this right and wrong business! Well don't waste all your tears now - they may come in handy later on - for to cry without tears hurts much worse!

I have your picture on my wall and a letter with many xxxxx - send another - I have a funny little - ugly little room - which is saved from being too ugly to live in because I have geraniums in the window - potted - bright colored - flaming geraniums —

- and now good-bye - and I'll bet I can send more kisses than you can!

xxxxxxxxxxxxxxxxxxxxxxxxxxxxxx

*Undated*

xoxxxxoooooxxxx
Tuesday
Neil is at Jack's
Dear Daddy

ooooooooooooo I am going to write all week to Daddy.  xxxxxxxx The box came and
went away again and didn't have time to catch it.  We will go get it.  We have our tree all
decorated up, presents under it too.  I think I'm going to get a violin.
I wish you were here Daddy
    Cole

January, 1925
Dear little funny bunny —
- were you happy to have your brother with you again? - well you and I shall have
some grand times together - soon too —
    xxxooo   Daddy

February, 1925
- to a very nice brown-eyed boy named Cole -
Daddy received your nice letter and thought it was a dandy!
When I get the next chance you shall have a trip somewhere - perhaps on a train or on a
boat!  I know you are a bit lonely - but so are we [Neil and Edward] up here [San
Francisco] - and just think how much Neil
and I shall have to tell you when we meet
again - I send you love and kisses - lots of
them —
    Dad

*Undated*
Come home to me soon
    Your baby Cole Weston

*San Francisco, 1925*    *Edward Weston*

March, 1925

Good Morning Master Mischief!

The sun is just spreading its light over the great harbor of San Francisco - everything is clear and sparkling - little boats and big boats dot the water - great ocean liners - busy tugs - fishing smacks - ferries - a wonderfully beautiful sight - a place to dream in this - if one had time or inclination to day-dream - but this world has no place for dreamers though it is glad enough to use the things that come from dreams providing they cost nothing! - and sometimes the world is very much afraid of dreams if the dream be more than about corn-beans or cabbage boiled - and if one were to pour claret on strawberries instead of cream and sugar or put a dash of cognac in his coffee in place of "canned cow" something terrible might happen to the poor fool who dared to try such outlandish experiments - if you are a good boy and grow up to think and act and look just exactly like your neighbors they will respect you and honor you - life will be simple and no doubt you will reap a just reward and like the ending of all good fairy stories - you will live happily ever after! or get your reward in heaven —

I loved your letter - write me more - I'm coming home soon - I'm so lonesome - how is "Pung" that nice pussy cat? and are your wagons still strong? tomorrow or the next day I'll write Neil —

many kisses and hugs -
Daddy

*These letters are from Cole to Edward and Brett in Mexico*

Dear Papa

Thanks you for dolls and baskets and the dolls were most all broken. The long baskets hang on my charros's arm. The Mexican shoes fit me well.

kisses    kisses    kisses

x x x x    Baby Cole Weston

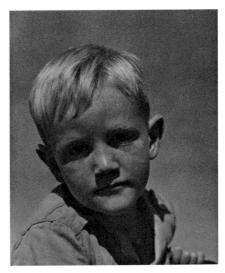

*Cole, 1924*          *Edward Weston*

Dear Papa —

I have new rubbers and new shoes - crepe

soles and umbrella stockings and handkerchief so did Neil.  Aunt Mazie gave me a valentine with candy hearts.  Neil had a sucker.  My teeth are all right Dr Burt says.
When are you coming home.

     Kisses and love

     Cole   xxxx ooo

February 22, 1926

Dear Daddy

xxx ooo Bingo is here sometimes.  He is not killed.  When are you coming home?
My teeth are coming in good.

     Kisses and love

     xxxxxx Cole

March 24, 1926

Dear Papa

Are you well?  When are you coming home?

     oooo xxxxxxxx

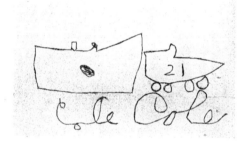

     Happy Birthday

     Cole W.

The dog is howling.  It is Bingo  Brett  He
loves us - we will save him for you

     Cole

     Undated

     Dear Dear Daddy

     When are you coming home.  Are you homesick.  I have a black cat.  Her name is
Blacky.  We are cleaning up the yard a little.  Cut down a big tree for the grate.

     I love you

     Cole

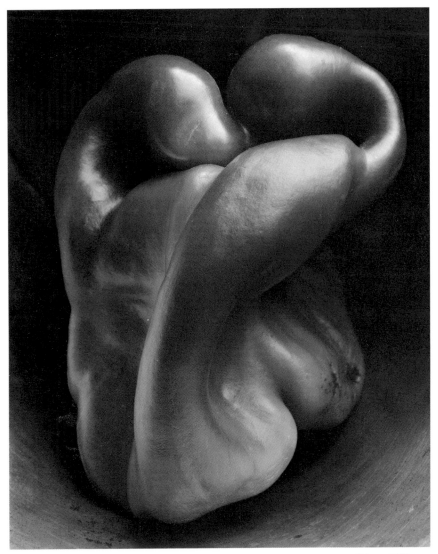

*Pepper, 1930*                    *Edward Weston*

# 1928 - 1934

On December 21, 1928, with seventeen-year-old Brett, who will act as his assistant, Edward moves his studio to Carmel. The next day the local newspaper, the Carmelite announces his arrival, reporting that he is "known over the country as a significant creative force in the art of photography," and continues, "the difference between a photographer and Edward Weston lies in the passion with which Weston approaches his work." Weston's passions include his sons. "Daybooks" editor Nancy Newhall's description of Edward Weston's sons as "his deepest human relations" gives us perspective on the devotion Edward felt for his four boys. Numerous lovers and mistresses enter and exit his life, but his boys seem to be his touchstone, bringing him joy and painful challenge. When Cole is quarantined at his mother's home with diptheria Edward leaves Carmel and goes to him sneaking in a rear window in defiance of the quaratine.

From April 1929 through 1932 Neil and Cole live with their mother in Glendale and spend extended periods of time in Carmel with their father and brother. With the same sense of truth and integrity that he applies to his work, Edward tries to discipline his energetic sons fairly, sometimes with serious consequences.

Edward writes in his "Daybooks," "Almost at once, the peace we had ended, the clash of personalities began, Cole the restless, excitable, exciting others, mischievous, — but a dear, fine boy, with a certain sadness beneath his roguishness."

On one occasion Brett, now nineteen, gets into a dinner table squabble with Cole, eleven. Brett pushes Cole's face into his food; Cole retaliates and gets slapped in the face by Brett. Edward sternly admonishes Brett and the next morning Brett leaves home with Edward's reluctant understanding that he is no longer a child.

Just a few days later Edward visits Sunset School and talks to the children in Cole's and Neil's classes and shows them prints from Mexico and Point Lobos, as well as

photographs of vegetables, bones and shells.  He later writes, "More fun to talk to children than to grown-ups."

Una Jeffers brings Edward an author's copy of Robinson Jeffer's new book, "Thurso's Landing," and Edward reads aloud to the boys and his new lover, Sonya, a young woman in her mid-twenties Edward has met at a party in Carmel. Cole says, "Dad, that's as exciting as a wild West movie!"

Edward and Sonya live together for five years.  The boys call her "Scrawny Bitch." Sonya does most of the household chores, including shopping for groceries.  One day at Espanola's grocery in Carmel she buys a pepper and takes it home for Edward to photograph.  Putting the pepper in a funnel, Edward makes a four-and-a-half hour exposure. This pepper, one of many he photographs, becomes known as 30P - Pepper, 1930 - one of Edward's most famous images.

All four Weston boys at some time during their lives follow in their father's footsteps as photographers.  Some of Cole's first photos are taken at age thirteen with a camera he says he acquired in a trade with Brett for a pair of "cords."  Brett always claimed that Cole just took the camera.

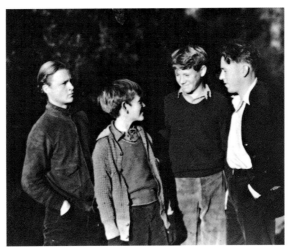

*Brett, Cole, Neil and Chandler, c 1930      Edward Weston*

*Undated*

Dear Daddy

I am awaiting your arrival to take me to Carmel.  [Cole is recovering from diptheria.] I am eating eggs, toast crumbs, chicken, persimmons, avocados, and other fruits and vegetables juices.  The quarantine is to be taken off tomorrow, Wednesday, Am feeling fine.  The boys treat Mom terrible.  She is a wreck.

Please write to me and tell me your plans for the trip.  I take sun baths and am learning to walk.

XO Love Cole X

P.S. here is some of my drawing show them to Neil.

XO Write me

*Cole had been visiting in Carmel.*

April 12, 1931

Dear Dad

We arrived a week ago yesterday at 6:00.  Sunday I made my rabbit cage then that night Chan took me and I got two small light brown rabbits a male and female for 50 cents apiece.  The next day Aunt Lilley brought me a small white rabbit with pink eyes they are all fine.

Mother has been sick for four days and I have done the house work made the breakfast and everthing.

Love to my little papasdo or Papa,
Love to Neil Chan
tell Neil to WRITE ME

*Edward Weston*
*Flora's home in Glendale where Cole remembers curling up by the fire.*

*Speaking of Cole, Edward records his son's observation, "Just think Dad, Octopi have eight testicles."*

May 19, 1932

- Cole and Neil —

Dearest ones - we will return Saturday sometime
Willard [Van Dyke, friend, photographer and cine-
matographer] driving - Had a very comfortable trip
up, arriving by one o'clock.  Hope you are getting
along without us —

I mailed your "cords" yesterday - also several
pairs of sox - three pair for Neil - because Cole got the
new "cords" —

Much love from your Dad

1932                    Cole Weston

July 8, 1933

Dear Dad,

I wish you could find some means of getting me
up there because I can't find a way up.  If you could spare
the money until I get it to pay you back for me to come up I would appreciate it very much
because I want to get up as soon as possible.  Chan can get up but I can't.  I am dying to
come up.

Please wright me

Lots of love

Cole

Undated

Dear Dad

You need not look for a ride for me because I
am driving up with Brett.  Tomorrow another boy
and I are going to the beach for a swim.  Will see
you next week.

Love

Cole

1932                    Cole Weston

September 10, 1933

Dear Father,

How are you?  I hope you are feeling all right.   I just returned from the beach with another boy.  We sure had a good time. I have a swell stamp collection.  I wish you would send me down all the stamps you can find, especially American - any kind.

I start back to school Monday.  My bike is in good condition.

Lot of love

Cole

P.S. Write me please

December 31, 1933

Dear Dad

How are you, I am sorry I didn't write you sooner but ever since Neil came I have been very busy.  Neil left today and it has been raining steadily without stopping once.  I hear you have a radio. I wish I could be up there with you.  When are you coming down. When Neil arrives ask him to be sure and remember to ask Sam [Colblentz, a friend of Neil] if he has any duplicate stamps he doesn't want I would appreciate them very much. When you come down with Brett get my book, "Van Laons Geography" from Brett he has not returned it yet and I would like it for  school and also my record, the one Sam gave me. Mom has been on a fast for a week and she doesn't feel like writing just yet.  We went to see "Alice in Wonderland" at the show.  I suppose Neil will tell you all about it so I won't. When are you coming down I hope soon.

Love to all

"especially you"

Cole

P.S. Mom will be pleased to see you and Brett and so will I.  Come as soon as possible and be sure to come so you can stay for a long time.

February 6, 1934

Dear Dad,

How are you I hope you are well.  I want to thank you for the two dollars, boy can I use it and thanks a million for all the nice stamps.  Wasn't it a coincidence that my birthday happens to be on President Roosevelt.  When are you coming down I hope soon.  I appreci-

ate your lovely letters ever so much they give me so much pleasure.

    With lots of love

    Cole

P.S. Tell Neil to send me a picture of his boat.  Thanks

*Neil and Sam Coblentz built a seventeen foot sloop, "The Goon" which was later purchased by John Steinbeck.*

*Sonya, 1932*                      *Edward Weston*

    March 23, 1934

    Dearest Edward,

    Your prints from Increase Robinson came last Saturday - packed in a huge wooden box - Have called Mrs. Hunt twice about the finish portraits, but so far she has not called for them.   Shall I mail them?  About the camera I shall gracefully and grateful accept a 5 x 7, I do see your point about supplies etc., and that is that.  Someday I shall own an 18 x 20 or larger, weighing not more than five pounds including paraphernalia.  I am an optimist you see.

Our party 1ast Saturday night was a grand success.   Fourteen were gathered around the cozy fireplace - of course, we missed you terribly, beyond that there was nothing to do about it, except, to possibly repeat it when you return and are rested from your excesses in the fair Southland.  Well, Edward my dear, at last you have a rival, sad but true, in the charming art of solo dancing.  We all acknowledge that you are a master, a great artist, you have won your laurels by wide acclaim, though your maturity and subtlety cannot be considered.   Well, darling Leon [Wilson] was so screamingly funny that he had all of us rolling on the floor, holding our tummies, gasping for breath, and tears streaming from our eyes from so much laughing.  What a delicious sense of humor that boy has - an asset to the kind of parties we like to give, when we do!  You must see him perform.  His sister [Charis] is no mean gal in that field, though a little restrained you can feel some pretty hot fires there.  Your two sons conducted themselves the well known Weston way.  Neil as the man host did himself proud, always thoughtful and in an unassuming way saw to it that his guests were never bored.  You should be proud of him.  Cole was deliciously adolescent - he would put on a dreamy waltz or soft tango on the phonograph and hopeful wait for Mary to glance his way.   He never would ask for the dance with any girl.  So finally when I saw that dance after dance would go by and he did not take the initiative, I whispered into

Mary's ear to ask him to dance with her. - Well the world became sunny and hopeful for him again. He dances remarkably well too. Well, we went to bed 3:00 a.m. I hope I have not bored you with this lengthy dissertation.

I will have enough money to last me probably until next Monday, so if you plan to stay longer (though wonder if it is advisable, because there are a lot of people in town and certainly a lot more next week on account of Easter holidays) it will be necessary to mail a check. We are having beautiful weather, balmy and sunny and probably is attracting people to come here. Let us know when you plan to be back, mainly because of possible sittings and then can plan appointments accordingly. Will mail the jacket immediately. Greetings to everybody there, and much and all my love to you dear.

Sonya

*Included with this letter is the following:*

A HALF HOUR CONVERSATION BETWEEN COLE AND SONYA

Dialogue: & subject matter or on how to be philosophical at 15
Setting: Living room - one light on a dying fire - time 12:30 about midnight on a Friday (tray of things and a half slice of toast, fragrant Roquefort cheese, (one lemon slice) - Bach records lying on table. As the guest is about to depart, footsteps are heard on the porch. Very loud footsteps and Cole enters - he looks this way:

Cole: Wheww!! Whewee I am tired - Gee, what a party God, it was swell - I never danced so much in my life - I am the best dancer - Gee Johnny was jealous, David sat in a corner and looked chicken - I danced with what is her name yes Ruth Austin gee she is swell, swell!! Godddd Sonya I had a swell time I never gee, Godd it was swell, oh, boy and did I eat, god the food was swell I never ate so much in all my life - I danced every dance - Patty is a swell dancer, geeee I am good - never stepped once on her feet, we glided smoooooth, god it was fun - David is prutty good most the time sat in the corner and

*Cole, 1935*

geeee - John wiggled stayed in one spot and heaved with his shoulder - god and he said he could dance better than me - goddd it was the most fun.  Gee I made one of the fellers mad, god was he mad, because I danced with his girl twice, I wasn't hogging it - he was mad because he couldn't have fun - I don't care.

Sonya: I want you to meet So and So.  This is Cole, Edward's young son.
Cole: Hellow!  Godddd I had a swell time - it was the best party.
So and So: I am pleased to meet you, Cole. (Smiling) Good-night.
Exit guest

Cole: Geee what a party!  My feet, gee I am tired (bends feet, arms flying wildly, body bends slouchily) Gee what fun, Godddddd, never ate so much in my life - gee I danced every dance.  One girl was homely - boys wouldn't dance with her -
Sonya: And did you dance with her?
Cole: Sure, she wasn't so bad and the boys didn't think I was cutting in on them but she was half bad - I danced with a good-looking girl and the dirty looks Johnny gave me, I most practically danced every dance with her godddd Johnny was sore, I didn't care.

Sonya: Was she Johnny's girl?
Cole: (Disgusted) Yah.  You know Patty is prutty good dancer I didn't step on her feet once she isn't half bad.
Sonya: Patty is a very nice girl.
Cole: Yah, her figure isn't half bad - I guess she'll thin out later, Godd, it was swell, (getting sleepy) gee I am tired, what fun.
Sonya: Cole, tomorrow is Saturday and you will be able to sleep longer, well, I think we had better go to bed.
Cole: I guess so, Gee, I had a lot of fun, godd I am tired, I sure am going to sleep, good-night Sonya.
Sonya: Good-night, Cole, sleep well ....
Cole: Yahhhhhhhhh -
(At breakfast the above dialogue is repeated word for word.)
- 2nd act -
The art of playing tennis - or I am SWELL.

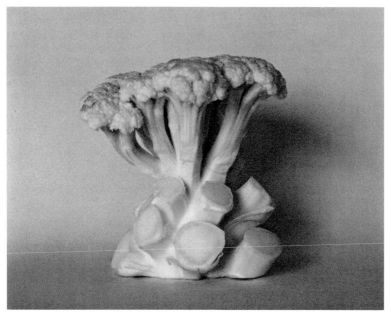

*Cauliflower, 1936*                    *Edward Weston*

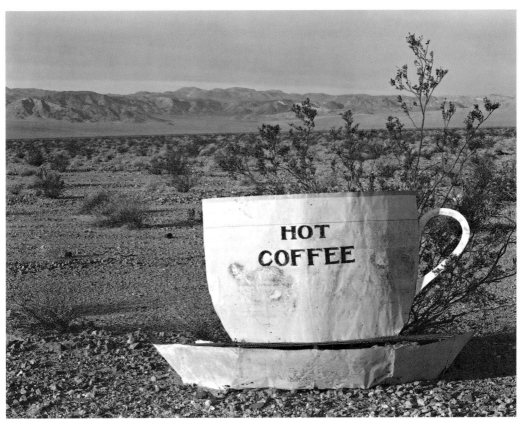

*Hot Coffee, Mojave Desert, 1937*                                    *Edward Weston*

# 1934 - 1940

On April 22, 1934 a new and important chapter opens in Edward's life. He meets Charis Wilson at a Carmel concert and embarks on a relationship with the eighteen-year-old he believes will stand the test of time. Saying he is now "too busy, busy living," the forty-eight-year-old artist abandons his "Daybooks" but continues to write to his sons.

The Depression Years bring more changes. Edward returns to Southern California in June of 1935 and rents a house in Santa Monica Canyon where he lives with Charis and re-starts his portrait business. In March, 1937, after twenty-eight years of unconventional marriage, he asks Flora for a divorce. The same year he receives his initial Guggenheim Memorial, the first grant given to a photographer, allowing him finally to work on his images free from the constant worry about money. The project, one of several, is titled "Making a Series of Photographs of the West." It lasts from April 1, 1937, to April 1, 1938, and earns Weston $2,000.

Edward, even though he doesn't drive, buys a new Ford V-8 sedan with some of his grant money. He calls the car "Heimy" in honor of his sponsorship and enlists Cole to help Charis meticulously pack it with photographic equipment in preparation for their first out-ing. Destination: Death Valley. Eighteen-year-old Cole is the designated driver, but he is not allowed to go over 35 mph so Edward can view the landscape and scout possible images to photograph. Less than one hour on the road, Edward calls a halt to examine some grape stumps. He then gets back in the car only to stop again a few minutes later. This time he unpacks, sets up the camera and works. It takes Cole several hours to repack the car.

Drama and adventure are common place for a teenager like Cole, growing up in the creative atmosphere of a village of artists. Even though he never knew her, Cole's passion for the theater can be traced to his paternal grandmother, Alice Jeanette Brett Weston, a Shakespearean actress. Described by childhood friend David Hagemeyer as "a naturally

extroverted actor," blonde haired, brown eyed Cole, the flamboyant ringleader of his high school chums, loves theatrical high jinks. He stuffs oranges in his pants' pockets and swaggers along Carmel Beach. When Cole and his friends want to hop over the hill to Monterey, he clowns on the road side to entice motorists to stop and give them a lift. A senior year part in a school play puts his future in focus. When Edward wonders what vocation he will pursue after graduation, Cole replies, "I want to act, I love being part of the theater at school."

Edward contacts an old friend, Nellie Cornish, who owns the Cornish School of the Arts in Seattle, Washington. Edward arranges for Cole to be on a work/study program and trades some prints to pay the tuition. During the summer months Cole works in a Monterey sardine cannery and paints houses to earn extra money for his clothes.

Cole's first interview with Miss Cornish goes like this:

Miss Cornish: "And what do you do?"

Cole: "I paint."

Miss Cornish: "Oh, do you use oils or watercolors?"

Cole: "No, I paint houses."

Cole had spent the summer painting houses for $2.00 per day.

During the summer of 1938 Neil, who is building a thirty-two-foot ketch, "Spindrift," uses his carpentry talents and builds a simple house for Edward and Charis on property owned by Charis's father in the Carmel Highlands. The initial cost is $1200.00; $275.00 for Neil's salary, $10.30 for a stove, $19.83 for a septic tank and the rest for miscellaneous materials. Edward and Charis move into the house in late August, 1938 and marry in 1939. Because the house is located next to Wildcat Creek, it becomes known as "Wildcat Hill." At the same time his father is moving into his new home, Cole meets Dorothy Hermann, a student of modern dance at Cornish School. Dorothy gives up an opportunity to dance with Martha Graham to be with Cole.

Neil and Cole  greetings and love from Dad!

Am anxious to be through with this work, and return.  A party is being planned for Teddie [Edward's first grandchild.  He and Edward were both born on March 24] and me on Saturday.  I may be finished by then - yesterday (Sunday) I made 24 negatives of exhibition rooms at the Exposition Park.  Got there at 7:30 before they opened officially, and was through before 11:00.  Chan helps by developing at night.  PWAP will ship me several hundred water colors to copy in Carmel.  [Edward was photographing the paintings for the Public Works of Art exhibition at the Los Angeles Museum.]  Have made well over 100 negatives since arriving.  Have you been doing your respective "jobs"?  Expect everything finished when I return.  Brett may arrive down for my birthday party.  If so I will return with him as far as Santa Barbara.  He wants me to meet Mrs. Dibblee - no chance the last time.  But I will not delay long there.

I miss you all!

Dad

February 2, 1937

Got card just as about to wire you.  We leave Wednesday morning. Early.   Drive straight through very important work re: Fellowship:   Regrets to all my friends.

Love, Dad

April 29, 1937

At Twentynine Palms, rocks that are similar to Dead Man's Point, but makes latter look like peanuts.  Cold, little rain one night and wind.  Miss you.  This for the family.  Off to crater near Amboy

Love, Dad

*Cole and Edward before the first Guggenheim trip*

July 12, 1937

Cole Boy -

Sorry we missed you by 15 m. Glad you have work. But take care of yourself. Brett quite put out because you used his name. Also opening wine and flooded toilet. Too bad. I have a bad case of poison oak [Edward also called poison oak vegetable syphilis].

Greet boys.

Love - Dad

July 18, 1937

Cole Boy -

We leave Monday. Will miss you. Poison-oak better. Don't over do by missing your rest. Neil has lost 10 pounds. You both have tough jobs. Good for your moral!!! All love to you from

Dad

*When Edward received his Guggenheim, Flora requested a family portrait be made. This photograph is the only one of the entire family.*

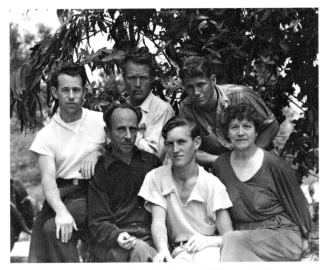

*Chandler, Brett, Neil, Edward, Cole and Flora, 1937*

August 3, 1937

Cole Boy

Miss Cornish said that she wrote you too. I am leaving with Ansel [Adams] for Mt. Whitney and will not return in time to take you north as I had hoped. I would give up this trip, but the opportunity to go with a guide is too important to miss. Maybe it is better. You will have a Xmas vacation. I will take you and John [Short, Cole's best friend] on a real expedition, if you like the idea.

Willard [Van Dyke] "rang in" a friend on our trip north, much against my better judgment. We intended taking two cars but his needed repairs and he couldn't wait. We were pretty crowded, in fact too crowded for working, but he accomplished his end of

doing a series of me in action, movies, and stills which will be of value to us both if sold. I will be back by end of week. Write me at once what your bus fare to Seattle will be. I will send a check and cover your first months board and room.

I understand the school is very strict. Breaking rules means fired on first offence. I sprained, or wrenched, my bad knee on last trip. Fortunately I get around with a limp. I have taken my 8 X 10 up granite cliffs which have never seen an 8 X 10 before. Brakes on new Ford are no good, grab, can't be fixed except by new installation. Factory admission. They install free if a car has been driven less than 8000. We have gone over 9000. Will cost me $15.00

All love to you and all -
Dad

*This letter was written to Cole while he was living with his mother.*

August 10, 1937
Cole Boy
Your card. What are your "certain difficulties", - that is if you can, or care to tell me. Wish you could have one more trip before "school" starts.
Sorry you have no food. Not pleasant. I sent Flora $5.00 yesterday, a small amount but I have my own difficulties. Just paid $15.00 rent, $40.00 car, $50.00 stock bill, car repairs $9.97 (including a tire vulcanized), expense of 1st trip north. And now I must start for Yosemite. If you change your mind about going along, let me know at once.
I wrote Nellie Cornish, thanking her and asking her to write me here when she wants you. So if you are here or in L.A. I can let you know at once.

Much love Cole, and to Neil and his boat and to Jane [Waterman, Cole's girlfriend]
Dad

*This postcard is written from Crescent City, California.*

August 11, 1937
At the top of California. Start south today. So want another trip before Seattle? Write me return mail. Love to Flora.
Dad

September 25, 1937

Cole Boy -

Glad the check is accounted for. I did not question your need of it, but thought you had not received it before leaving L.A. Also I did not realize, though I should have, that your initial expense would be so much. It is both fortunate and unfortunate that I am on a limited budget. At least I have a definite amount coming in and know just how much I can spend. The money to you and to Flora put me pretty low. But don't for one moment think that I begrudge the money sent you, or that you need think of "repaying" me. My one regret is that I can't send more so that you would have a little spending money. I hope that I can do more for Neil someday; maybe help him with his boat. My pupil has not appeared, so I am going to ask the "Foundation" advance money to carry on. I am leaving for the Klamath River trip the first of week, to be gone several weeks, so I am enclosing your next month's check now [Edward sent Cole $25 each month for school].

I note you are in bed with cold. Hope you are better, Take care!

You may have heard that I am going ahead with the divorce in S.F. This is my due. I have waited 15 years for Flora's sake, "because of you boys". I have many reasons for doing this aside from the one which everyone seems to take for granted, - that I wish to marry again. I have not yet announced my "engagement!" I gave Flora first chance to get it, to bring charges against me so that she would not be damaged by accusations. She would not do it so she will have to take the consequences, - though there should be none. I am writing you boys because of a letter received from Flora which seems quite unfair. Quote: "Your children and other near relatives asked me not to divorce for fear you might marry C. [Charis]. The boys said if she were your wife they would remain away from you. I knew, in time you would find your sons' company more than that of any woman."

This pinning me down to a choice I refuse to even recognize as an issue. I have, in my own way, tried to do all I could for you boys. But my personal life is my own. I have never tried to force my friends to like each other, but I never take sides. My love for you boys is a deep one and had no comparison with my love for anyone else. If "the boys" (note that Flora used no names) wish to "remain away" I will have deep regrets, but I cannot be coerced by such threats. What would be the thought of me if I remained away from "the boys" because I did not fancy Cicely [Brett's second wife], Elinore [Brett's first wife], Max [Chan's wife], Jane [Waterman, Cole's girlfriend], or Joan [Neil's girlfriend]. And Flora writes "I was trying to save the boys for you." I don't need any help, I am not making the decision, it's up to "the boys".

Always my deep love

Your Dad

October 30, 1937

Dear Dad,

I am terribly sorry I haven't written you sooner, but in your last letter you said, you were going on another trip. I thought you would write me and let me know where you were, so I didn't write. How many trips have you been on? and where have they taken you?

I am getting along well at school, I certainly am crazy about it. I am taking up radio broadcasting. Miss Cornish said when I wrote you, to tell you to come up here on a trip. I am going to move into an apartment with another boy. It will be much better, and just as cheap. I am moving the ninth, so I hope you can have the check here on time. I will let you know the address next time I write.

How is G.G. [Guggenheim]   Is it still running as smoothly as ever

The weather up here is cold and I don't mean maybe   Jane sends her love to you.

Well Pops write me soon and I will do the same

Love

Cole

November 25, 1937

Cole Boy -

Thanksgiving Day - and hoping you have at least - a pleasant one. We are invited to dine with Zohmah and Jean Charlot. I have not seen him since Carmel Days.

Two more of your letters were stuck under my door. The last one had no date, so I can't tell if it was written to Flora before you got my air-mail or after; it could be either. I liked the spirit of your letters, and can see that you have guts, and will accomplish what you have started. You had guts to work in the cannery for your clothes, and to go without lunches in Seattle to save money. I went without lunches in

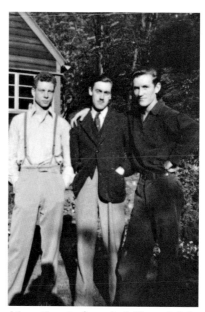

*Merse Cunningham, Jack Tyo and Cole at Cornish, 1937*

high school to save for my first camera, and I lived on peanuts at the college of photography in order to get through. So be careful how you treat your engine. Apples should be reasonable in Seattle, eat some for me; and take 1/2 lemon in glass of water when you arise. Leaving out certain items in ones diet is more dangerous than eating foolishly. Here is 5

bucks for fruit. Much as I want to see you it is more important that I feel you are well fed.

This is a great adventure for you this being away from home, and I am all for it. I will not fail you in any emergency if I can help it. But you must have a definite understanding with your mother on her share of the expenses. I do not see her, as I told you, so it is up to you to make matters clear. You will get my 25.00 regularly as long as I still eat. But you should write at once and find out where you stand. I have watched proceedings for 15 years and know where of I speak. Flora is generous to a fault, but in her own peculiar way. Please do not think that I am placing myself on a pedestal. Enough!

Seattle in snow must have been beautiful. We spent 5 days in the lava-beds, N.W. California, almost to Oregon line, in rain with snow just above us. Frost mornings, so cold that trunk door froze and couldn't be opened until boiling water was poured on it. Put up tent and worked between showers. Couldn't leave because Klamath River road was dangerous in rain. Have many stories to tell you someday, - of bears, ants, mosquitos, of glass mountains, and ice caves. Someday.

Until then, my deep love

Pops

Longest letter I've written since Guggenheim started! Your check will be sent by the 1st.

January 5, 1938

Here is your stipend dear boy.

We are with Frederick Sommer [photographer] for a few days. Cold nights! Awaken stiff - Have no mail for two weeks, so don't know what's been going on. Hope you had a grand holiday. Real regret that we missed, but I've determined to make Seattle - if I get an extension - which will be better. Will write more from L.A. Do write me a line of news.

All love, Dad

January 5, 1938

Dear Dad,

Well I am back in Seattle after having a vacation I won't forget for a long time. There was only one thing wrong and that was your absence. I hope you can make it up here this spring. I had a swell New Year's party in San Francisco with John [Short], David [Hagemeyer] and Bill. I was a little disappointed with your pictures in "Life" what do you think?

I am finding it very hard to get back into the swing of school again, after having such

a swell vacation.  Pops when you get this letter will you send me my check immediately as I am flat broke.

Well Dad I hope I will see you very soon

Love

Cole

Brett and Cicely          Edward Weston

January 15, 1938

Dear Pops,

I guess you are in L.A. by now so I'll write you there.

Well I guess Brett broke the "Weston curse"[Brett became the father of a little girl, Erica], of all boys in the family.  It calls for a celebration and I wish I was there to help out.

I certainly hope you can make it up here, maybe during spring vacation, then we could take a trip somewhere, try and make it, will you.  I am dying to hear about all your experiences. I am back into the swing of school again, and am having a swell time.

How is G.G. is she still standing up alright, I certainly hope you will get an extension, you deserve it, if anybody does.  Well Dad here's hoping I will see you in a couple of months.

Your admiring son, with love

Cole

January 22, 1938

Your very good letter at hand.  I do appreciate your writing, for I know you are busy. So am I.  Just finished developing 160 negs and printing 2 mos for "Westways."  We leave for Yosemite soon, I think with Neil.  When is your spring vacation?  I will bring along some work for Miss Cornish to select from for the school.  Much love until next -

Dad          Pops

February, 1938

Happy Birthday to you          Edward

"                              "          Neil

Happy Birthday dear Cole

Happy Birthday to you!

A little late! Neil remembered on the day.  We have camped three days on the Borego Desert.  Raining now, so we are pulling out -

Two bucks for your birthday -

and much love

Dad

Happy Birthday to the greatest potential Shakespearean that ever trod the boards - Here's to you kid, and long may it wave!

Charis

March 1, 1938

Cole, dear boy -

Just back from Yosemite.  Neil went with us.  He and Charis went skiing while I photographed one day.  This is only one item from a glorious trip.  I went wild, photographically speaking, averaging 14 negatives a day, - over 80 all told.  Have never seen such snow.  But more of this when we meet.  When?  I somehow did not realize that spring vacation would be so soon.  I will not know until about the time it starts whether or not I will receive an extension, and I can't plan until I know.  If I get one, I will have to take immediate steps to move because this place is impossible inconvenient lot living in any length of time, and I will have to remain at a base and print, at least half of next year.  If I don't get a renewal I will have to move anyway, find a "Business" location, and start earning money, - for one reason to keep you in school.  I have explained at length because I did not intend to raise false hopes about a trip north. However, I have an idea.  You have a summer vacation? We could drive up and get you, go on a trip together, either explore the north or go into the Sierras or Redwoods, then bring you down here.  What think?  I would be glad to give a show at the museum, especially while you are there, but not now.  I have done no printing for myself this year, so could show only work prior to Guggenheim.  The photographs on hand are in very bad condition from much traveling, so I would prefer to wait.  But I do want to give Miss Cornish a selection for the school if she would like them.  I will bring some when I come.

Let me know if summer vacation plan pleases you.  And I will be very definite this time.  Of course granting I get renewal, which I feel quite sure of.

We leave for Death Valley, Thurs.  Will think of you. Here is check for next month.

Much love, Dad

"Pops"

March 15, 1938

Dear Pops

I certainly hope you can make it up here this vacation, is there any hope??? If you can't I guess I will just have to be patient until summer which is a long ways off.

*Cole (left) at Cornish School, 1938*

I have never been so busy in all my life, I am at school about 14 hours a day working my fool head off on Modern Dance concert, Eurzthmis Demonstration, Radio Show, Fencing Exhibition, Play rehearsal and every thing else, but I love it. I practically live at school I have to go back to school now and practice about three hours on the Modern Dance Concert which is to be given Friday and Saturday.

How was your trip to Death Valley. I certainly envied you, all it does up here is rain, we had a couple of days of sunshine last week.

I received the check, thanks. Did you see the article in the March issue of "Scribners" about F64. It has a swell print of yours.

Well Pops I have to go to school now so I will close (hoping to see you very soon).

Love

Cole

March 19, 1938

Cole beloved -

Think of you as we wind up this year's Guggenheim where we started, - Death Valley. Not much luck with weather - cloudy, cold, light rain to start with, then a desert wind storm such as I have never seen (or rarely). Down went our tent, bent metal, socket off where sections of pole join. Fixed with splints, and it held last night in another storm. But I hardly slept. All told, we have had about 3 good days in 8. Despite weather I have made 104 negatives. Not bad. Have worked a lot in Golden Canyon where you and I went last year. Have worked out a better system for work. Scout first without camera, climb any likely vantage point, not best time of day, then follow up. And what climbs! Often cutting steps in order to get camera up. Dante's View quite changed. The great salt bed is covered with water and not nearly so dramatic. The road up is now paved, and a snap to make.

Curry still here. Expect to go with him on more expeditions.

Burros visit camp at night hunting garbage and are almost as much nuisance as were the bears at Lake Tenaya.  Let me know how you feel about the proposed trip to get you this summer.  And let me know of any interesting doings in your work.  Carmel paper said you were to appear in play?

This is a long letter for me to write this year.  It is being written on a Sears Roebuck catalogue in my lap, sitting in car.  Too windy outside,   Will let you know when I get news of my application for extension.

Love Boy -

Pops or Dad

March 30, 1938

Cole Boy —

News, good and bad

Bad first: I cannot possibly get up for spring vacation.

Now good: I have the Guggenheim award for another year!

This is a secret until released for the press Monday next, April 4. So tell no one.  Now you and I can go on with our respective work without worry for another year.

Wish I had not given you hope of making Seattle now.  I could by the latter part of April perhaps, but better wait until summer vacation.  Please let me know soon, just when summer vacation starts, so that I can plan trips ahead.  Got your letter in Death Valley.  I was so happy to get all the details of your activities.  Go to it, I am with you.

We had terrible weather, rain, sand-storms, cold (only one fairly hot day), but I managed to make 175 negatives which I am now developing.  After I must print 3 months for "Westways".  So you can see why I can't leave.

I enclose your check now, because I may not have another letter spell before the 8th.

Much love dear boy

Dad

April 15, 1938

Cole Boy

The news of your near rupture was certainly distressing; you don't mention how - Take it easy, don't lose your head, keep bowels open so there will be no undue pressure, - but don't irritate them with laxatives no matter if prescribed.  Let me hear the outcome in next examination.  Nature can heal a broken bone, so she can heal a busted gut.  Are you

satisfied with your doctor?

So you did not have a spring vacation after all. And I could not have come up even if I had planned, for the very good reason that up to date I have had no stipend. Last year we were on our way by the 9th, bought car the 6th. I know it will show up any day but in the meantime it's a rather embarrassed condition to be in. Lucky that "we" got this renewal. Otherwise I would have had to start my professional career all over on nothing or next to.

As to my supposed marriage, etc, I feel like paraphrasing Mark Twain's "the report of my death is greatly exaggerated". I certainly would have told you if I had told anyone. Some reporter had a bright idea. San Francisco papers very funny.

I would love to be present at your play, but don't think I can make it up there by May 19th. Even though I am free in a sense, I have obligations to my project. I would have to combine work and seeing you. Working on the way on the trip to Seattle would take me at least two weeks, likely longer. If I could make it in time to see play, then I could not wait until the middle of June to take you on a trip. Better let me know which time you would prefer in case I can make a choice.

Harry Leon Wilson [Charis's father] had a stroke, so Charis and Leon left almost two weeks ago for Carmel. "H.L." lives alone, but for a housekeeper and everything was in an awful mess. Fortunately I had much work to do, and no money to travel anyway, so my plans were not upset. Neil has been a brick in helping me with the old Franklin and his strong arms.

Much love Dear boy,
Dad - Pops

April 22, 1938
Cole Boy -
Am sending check $7.00 to Seattle O. Clinic today. No word from you so I judge you are better. Pray so! Neil came over with the request that I send you 2.00, that neither he nor his mother could. I know Neil has not been working, but I also know that 200.00 [by Flora] was recently borrowed to help build Kinne's [Flora's friend] house. I dislike to be a tattle-tale but you must understand my position. I feel this is an attempt to squeeze all possible out of me. Since I am sending 7.00 the 2.00 should come from another source. Only fair! The fact is I'm nearly broke. Have not received my first 1938 stipend yet. Even when I do, I have to plan ahead very carefully. I am enclosing air-mail stamp so that you can write your mother an emergency letter if necessary. You will get your stipend in time if I have to eat dog-biscuits.

Please keep this letter confidential. I dislike explaining family differences but want you to know, where I stand. And please don't think I am trying to make you "take sides" in a disagreeable situation.

Deep love
Dad

May 3, 1938
Cole Boy -
Just your check today.
I may have interesting news of my next move in a few days. Will write you then.
Saw Jane [Waterman - Cole's girlfriend] Sunday. Neil and I drove down. A very sweet and lovely girl.
Love - until soon
Dad - Pops

May 17, 1938
Cole Boy -
Hope this reaches you in time to wish you all success in the play. I also wish that I could be there, see it. Things are moving fast. Charis left for Carmel with "Heimy" [the Ford that Edward purchased with part of the Guggenheim fellowship money] loaded to roof; Neil and I leave with balance of my effects in Chan's truck, this week. I am going to have a house, living room, dark-room, fireproof vault and toilet, when Neil gets it built! This the news.

I will not be able to drive up for you, on account of all this necessary activity, but we will drive you back if it's the last act of my life. I will send your stipend as usual. This you can use as bus-fare since you will not have rent to pay in June. Let me know if this works out.

You can stop off at Carmel Highlands (we are building on H.L.'s property) and see us. If you wish Neil will give you a job. He is boss of all construction,
Let me know soon your ideas and plans
Address: Route 1, Box 162, Carmel
Bushels of love. Dying to see you.
Dad

May 27, 1938
Cole Boy -

Neil and I drove up in Chan's 25.00 truck, - 16 driving hours.  We had a load which needed 55 lbs in back tires.  Neil and Sam are working on our house - one room plus darkroom.  The foundation forms are in, pouring concrete tomorrow.  When exactly does your school let out?  What day?  We have to do the mother-lode country before it gets too hot, probably start out Tuesday.  If dates work out, we could meet you at Brett's in San Francisco then bring you down here.  When you had enough of Carmel you could drive the truck back to L.A.  Then when you had a good visit there you could load the truck with balance of my things and return to Carmel.  By that time I would be ready for another trip and we could leisurely work our way up the coast to Seattle.  We could show you the most magnificent coast, camp out on beaches which are "plus"!

I am trying to plan so we can see the most of each other and have a swell time as well.  How does the plan strike you?  Let me know return air-mail what day you get away, what day you could be in San Francisco and the minimum you need in money for trip and expenses.  I had to pay cash for lumber so am short, but will have more July 1st.

Much love
Dad

June 28, 1938
Letter is sent care of Brett Weston
Cole Boy -

Hear that you have a job.  For how long?  Work here will not last more than another week or 10 days.  Could give you 3.00 a day.  Maybe you could make more.  If you could be here to drive back with Neil, you would save bus fare.  I would love to see you.  But maybe you plan to visit awhile before we start north en route to Seattle.  Let me know plans.

Love to you and la familia Brett
Dad

August 2, 1938
Cole Boy -
A nice letter from "Aunt Nellie" enclosed.
Good of Chan to give you his Ford.   Whether or not to drive it back to Seattle,

should depend upon economics. The temptation would be strong to use it when you didn't need to, - if indeed you do need it at all. Then you have to consider Washington licence and tax, garage, repairs ——
All this might be negated by the good you would get from it. So - ? You figure it out in black and white, negative - positive.

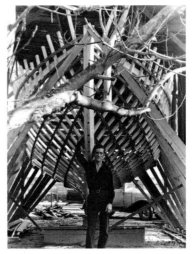

1938-1939       *Edward Weston*
*Cole with Neil's boat Spindrift*

Pretty strenuous here. H.L. had a stroke yesterday, in fact two. But he is strong as an ox! - and better today. I found my "pie - containers" were staining my negatives. Don't know how many I've lost. Must change the whole year, - over a thousand.
Sommers [photographer] from Arizona have been here on top of all else.

Glad you are to see Dorothy [Hermann - Cole's new girlfriend] soon. I am anxious to meet her after all your high praise,

Glad to hear from Neil of boat's progress. Much love to you, Neil, Chan.

Your "Pops"

*The following letter was included in this envelope.*

July 18, 1938
Mr. Edward Weston
Route 1, Box 162A
Carmel, California
Dear Mr. Weston

I am awfully glad to hear that Cole loved the school, and can only say that the school loved Cole. He is certainly a nice youngster and we shall be very glad, indeed, to extend to him the same scholarship conditions as last season.

I shall look forward with pleasure to your arrival. My best wishes to both of you.

Very cordially yours,

Nellie C. Cornish

August 11, 1938

Cole Boy

Tell Neil that they cut off several trains (mail) from here, so he will not get his answer until you get this! I gave Neil a list of odd jobs yet to do. If you want to do some of them and earn "pin-money" tell him which. I suggested that you come up at different times. I might have a better visit with you (we really have not had a genuine get-together). And there would be more room, less confusion. But decide this between you. Either way is O.K. with me. But how about your girl? Is she with you south as expected? The book [EW] promised her is coming up with the load. Sun today, - first time in weeks. I have kept at it pretty steadily in the dark-room, mostly experiments with every paper and developer, I'm getting somewhere! Will show you. Much love, and write me your decision.

I gather you have decided to drive your car north. If you can afford it, it will give us enough room for the Seattle expedition.

Dad

Pops

August 14, 1938

Cole Boy -

Neil arrived this a.m. pretty tired.

Expect you and Dorothy Tuesday.

Please go see Uncle Theodore and Aunt Mazie before you leave!

And please get my background roll from Peter Krasnow which Neil forgot. This is important. Give Peter and Rose my love.

See you soon     Much love

Dad

September 10, 1938

Cole Boy -

You were thoughtful to keep me posted en route. I was a bit bothered after you left that I had not allowed more for emergency. Hope the trip was not too hard on you and Dorothy.

I enclose several items, including your check for 40.00. This, plus the other check 25.00 - and dentist 18.50, makes a total of 83.50. Flora's share of 40.00, I will take out, as suggested, at the rate of 5.00 a month, starting October for 8 months or until next June.

As soon as I get a little extra, I will send you some "pin-money" for the work you did on car and house. I forgot the "sitting" of you and Dorothy that last hectic day. Will bring my Graflex with me when we make the northern trip. Guess it will have to be after rains in spring. Can't leave now; still waiting for Mr. Moe [president and executive of the Guggenheim Foundation]. And we go to Death Valley again in November.

You should see the place now! We had a chance to clean up, - after Jim left and Chan, Bill, Sophie! Jim brought a shower curtain, I cleaned the toilet - bowl with a razor. Charis put curtains up. We oiled the floor. In fact everything neat as a pin and function-ing smoothly. Glad Dorothy found a nice place. Take good care of yourselves. Don't work on your nerves. Eat a lemon - or good Washington apple - every day (just as important as eggs, bread or spinach). And keep your nose clean.

I think Dorothy is a grand girl, and I'm happy you have this companionship. Keep it on a sound constructive basis. (My grandfather - Edward Payson Weston - was a minister).

Enough for now. I have a rare head-ache. Apt to write gibberish -

Love to you dear boy

and to Dorothy

"Pops"

September 30, 1938

Dear Cole

- me too - "have been working like the devil". At the same time, many visitors. Most important, Mr. Moe, who is a very swell person. He only stayed one night; then we drove him to S.F. I can't tell you the details yet - because I don't know them - but there are pos-sibilities beyond my fondest dreams, in the way of subsidizing. Even this much is a deep, dark secret. Will let you know when I know. Warren Newcombe here, brought 7 prints, at a "rate". Dr. Frost and wife here. And Monday Ansel arrived with Georgia O'Keeffe and three Rockefellers. I routed them through Pt. Lobos. They will return!

Who is Mr. Foley of your clipping? I can't remember though the name is familiar. Anyway, I'm on the up and up in such stardom! I am happy with you over the new part. Have you a good director this year? Don't work on your nerves. You have much of me in you. I had to learn. 20 minutes, or 10, flat on your back, completely relaxed will give you a fresh start. Preaching again! Which brings me to my remark on "constructive basis" and your comeback. You are right, of course.

Hitler seems to have gotten all he wanted again. But he is not through. I certainly don't want war, but it's disgusting to see him get away with murder.

I got up at 6:00 to get in dark - room before it gets too hot on the west side, or to get through before the sun heats up our exposed water - pipe. We have no settling tank. Rain stirs up the soil, clogs pipes. Two rains to date. Sky-lite leaks! But nothing else. Brett arrives tomorrow with Cicely and Erica for week - end.

I enclose check now so not to have on my mind.

Lots of love, abrazos y besos, hom

floppy - dop to my little boy Cole and Dorothy

October 3, 1938

Dear Pops

I guess this letter will be sort of a surprise, as I just wrote you one, a day or so ago. You see Dorothy and I have been working up a budget. We have figured out the last days to have our money sent to us. Would it be possible for you to send mine so it will arrive on either the sixth or seventh of the month, if it will cause you any difficulties don't do it, but if it is possible. I wish you would do that for me.

This first month has been pretty hard to get through; there are so many small items we had to buy to get started with, dishes, pans, silverware, and plenty of split peas, Lima beans, and lentils in reserve. Everything is fine now, and we are both very happy.

Today winter made its entrance in the form of strong winds and driving rain. The sky is clouded with falling leaves, but it is very beautiful.

Well Pops I hope what I suggested about the check won't inconvenience you.

Much love from

Dorothy and Cole

October 20, 1938

Just a greeting to Cole and Dorothy - remembering work on car etc.

Glad you are happy -

Don't forget the lemon juice and keep your nose clean —

Love

Pops

Leave for D.V. [Death Valley] about 1st .

Your stipend before leaving.

October 23, 1938

Dear Pops,

I am sorry for not writing you sooner, but I have been very busy. We have rehearsals every night until 10:00 so you can see I haven't had much time to write in.

I have moved to 759 Harvard N. I have a beautiful big room with the most comfortable bed in the world in it. It is a hundred percent better than my old room, steam heat and everything and its not any more expensive.

The play is coming along beautifully. It goes on November 10 we have already sold 200 tickets to one club for the first night. I think the play will be a success.

Every other Wednesday I am on a radio program which is broadcast all over the state of Washington, it's lots of fun.

I have had a little trouble with my car, the same trouble you had with yours. Blown gaskets, no start and crank case full of oil more damn fun.

We have had beautiful weather up till now.

Miss Cornish has gone back east, she will be gone until after Christmas.

Dorothy and I are planning to drive down Christmas if my car is in good shape. Have you gone on any trips lately, if so what ones.

Dorothy sends her love    says she will write you soon

Write soon

Love Cole and Dorothy

November 2, 1938

Cole Boy -

Your long newsy letter and schedule was much appreciated. But don't take your valuable time and energy to write at length. I will understand if I only get a card.

I am glad you have a better room, and that the play is going well. Good work to you!

Did you get the 5.00 check sent to your old address? Here is one for November.

I have had a student for a month, so no long trips. But I have worked a great

*Cole dancing, 1939*                    *Peter Stackpole*

deal at Pt. Lobos. A new version.

Grand to see you at Xmas! We will not make the northern trip until rains over, - at least in Calif. D.V. [Death Valley] is next on program. Expect to leave soon. Taking Leon on his first Guggenheim expedition.

Love, hugs, and kisses to
Cole and Dorothy
Dad
or Pops
or Edward

November 21, 1938
Well Pops,

A little time to write so, Dorothy and I seat our selves across the little table and start to scribble, we really should go to bed as it is 11:00 and we have to get up at 7:30.

I received both of the checks, the extra five came in handy, as my car is on the blink. I think that its fixed O.K. now, at least for the time being.

The Play was a great success and there is a possibility we will take it on tour in January. I sure hope so. I'll tell you all about it when we meet. Dorothy and I are going up to Vancouver B.C. to have Thanksgiving dinner with her parents. They are really swell people, I get along with them very swell.

*Cole and Dorothy dancing, 1939*
*Peter Stackpole*

I have been working on the car whenever I have spare time in order to get it in shape for the long trip down this Xmas. I think we will leave around the 18th of December. If the car breaks down I'll sell it and we will take the bus. Well Pops I am getting so tired I can't hold the pen still so I guess I will quit and get a little sleep.

Much love and see you soon
Cole

December 2, 1938

Dear Dorothy -

Sorry I made you self - conscious!  Why?  If I like J [Jane Waterman, Cole's old girlfriend] can't I like another, - you?  Well I do, and tried to show it.  Hope I'm not forbidding.

As to "neither write interesting xxx letters", - anyone who has an interesting life can write if they put down no more than facts.  To do more that this one must be a writer.  But you are a dancer.

Your report on Cole, most satisfactory.  All but the "thinner".  If he gets much skinnier I'll have to buy him new clothes.  We have just had a light rain - so far all this years' rain has been light - and the sky - lite leaks, also under the front door - window where Cole weather stripped.  (Not blaming Cole).  Our house is splitting badly, great long cracks, especially on south-side.  Bought "bats" yesterday and will do some amateur carpentering today.  Guess lumber was too green.  Not so good for my darkroom!

A beautiful high sea today.  I am tempted to work on Point Lobos.  My recent work there has included exposures of 1/300 second on breaking waves.  Not that this is fast as others work, but it's unusual for me -   Now I must to work - This note carries love and a kiss when Cole isn't looking -

Edward

And Cole -

- time for your stipend.    Had expected to send it from Death Valley, but here we are, champing at the bit, delayed by business concerned with the estate.  Of course my time is not wasted for I have printed steadily, but it gets pretty tiresome to be in dark-room so much.  I have had some relief by working at Point Lobos and seeing it with new eyes. Will show you.

Now I am wondering if we will miss you when you drive south this Xmas.  I will try to shift time so as to be here, but plans for work come first because I only have four months left to go as a fellow [Guggenheim fellowship].  Next years' work - after Guggenheim - include articles for Camera Craft, and a book for the same publisher.  This is a book on photography, not on my Guggenheim year.  The latter book seems a possibility, also.

Glad to know about your play and other school work.  Why not Carmel on the tour? I'll get ringside seats - I somehow feel we will see each other during holidays despite uncertain plans, if not, we will make trip north this spring sure!

Much love darlings

"Pops"

December 15, 1938

Cole Boy -

Arrived in L.A. last night. Be here about a week, then Death Valley. Hope I don't miss you. Too bad we couldn't plan our itinerary better, but have been in such a mess of sickness (H.L) and what not. I have an idea, not well thought out, that perhaps if I bought gas, you, boys and "girls" could spend a couple of days with us in Death Valley during the holidays. I have not talked to Chan yet.

Don't come down over Ridge Road - snow!

Love - to you both -

Dad

January 24, 1939

Dear Pops,

I received your card, telling of your return, I was beginning to wonder when I would hear from you again. How was your trip to Death Valley. I certainly envied you.

We had a terrific trip back to Seattle. Blinding rainstorms, with thunder and lightning striking all around us; all the way from Dunsmuir, California to Seattle. Rain so hard it stopped the windshield wiper. Despite this we made it in less than 29 hours from San Francisco. I drove just about all the way. Boy was I pooped.

I read about your exhibition in New York in Time. I certainly am proud of my little "Pappy". I hope that someday I will do something that will make you proud of me. Are you still planning to come up here in the spring? If so maybe you could come up in our Easter vacation.

Last Saturday night we drove off into the wildness about 70 miles to an Indian reservation. They were having a big annual celebration. God it was thrilling, I haven't gotten over it yet. The damn Indians were crazy while dancing to the most powerful drums you have ever heard. It just sent one continuous shiver up my back. There were only a few white people there. We didn't get home until 4 in the morning. Will you still send up an exhibition? Let me know.

I have to go now so write me soon.

Love    Cole

January 30, 1939

Happy Birthday to you

"                                                    "

Happy Birthday dear Cole

"                                " to you

(this extra five is supposed to be "birthday") anyway it carries much love. This will be a snappy letter.   Today is moving day.   H.L. [Harry Leon Wilson, Charis' father] leaves the old home - for a room in Carmel - probably forever.   Ida and Ralph left Saturday.   The place will be on sale.

Thanks for your sweet letter.   I am proud of my Cole Boy and the guts he is showing. We are still planning the trip to Seattle.   When is your spring break and how long?

I didn't know you had two weeks to spare (at Brett's) on way home.   Wish you could have made it to Death Valley.   I will try to get ready an exhibition for Seattle, but can't say yet how soon.   How about "open" dates up there?   How many photographs can be hung? Tell me all conditions.   Will they be hung under glass?   The latter answered will help me decide what vintage of print to send.

Love to you and Dorothy

Dad

Got a greeting card from Xenia and John [Cage].   Remember me to them in mudo carino.

February 11, 1939

Dear Pops,

Thanks so much for the extra five dollars, it came in handy: also thanks for the swell letter.   I couldn't answer it sooner because I've been busy.   I'm certainly glad that you are all planning to come up.   Our vacation starts on April 1 and lasts for one week.   I hope you can make it up then.   We might be rehearsing some of the time, but I don't know as yet. About the exhibition.   The only open date is from April 6th to April 19th that's just after vacation, so you could probably supervise the hanging of the prints yourself, you could also bring them up with you and save the expense.   The room isn't a very large one, it's our reception room.   I don't know how many you could hang probably 20 or 25 anyway you can tell when you come up.   They will have glass to hang them behind.

We are starting on a new play "There's Always Julist" by John Van Druten, it a swell play but quite a difficult one.   So far I am playing the lead, but who knows what might happen.   We are also doing "The Amazing Doctor Chitterhouse," it hasn't been cast yet. Besides this I am working in "The Marriage at the Eiffel Tower" by Jean Cocteau.   Also we are recording radio plays which we direct and produce.   And besides all this I go on the air

over 13 stations over Washington on a medical program, take all my other subjects besides, fencing every night, build sets and do janitor work. It's fun though.

I was talking with Hector (our director) about the possibilities of taking a few of our plays to California this summer, for sort of a summer theater, he is very anxious to do this and he asked me of the possibilities of going to Carmel. The plan is to rent a theater and give plays, also teach fencing , theater, dictation and stage craft. Do you think there is any possibility of getting a theater? What about Croter is he still around? I think he is interested in Cornish or was at one time. If you see him will you ask him about it. I think Carmel would be an ideal place for such a thing with summer tourists and all that. We might even make a little money, but it is primarily for the experience. I certainly would appreciate it if you would maybe inquire around a little and let me know as soon as possible.

I must be getting old I got a bad case of lumbago in my left side a couple of weeks ago and had to go to the doctor and be all taped up. Its all right now. I had to go to the dentist last week because of a toothache. He pressed on the top of the tooth and the whole damn thing caved in, more fun.

We're having terrible weather snow for two days, then ice which made the streets blocks of ice, and were there smack ups. I practically had to crawl on my hands and knees to school, so I wouldn't break my neck. Now we are having a terrific rain storm, with the wind practically blowing the house down.

Well Pops I guess this is about all the news there is. It's a record letter eh?

Write me soon.

Much love    Cole

P.S. Give my love to Charis.

February 14, 1939

Dear Cole

If shirt is not what you want - Keep it until you can send it to me and I'll get 2 not so woolly. Don't give it away for Neil gave it to you. I bought 2 for him so you got me - How are you both. Neil some better.

Write

*Dorothy Herrman Weston, 1946    Cole Weston*

February 28, 1939

Your "record letter" is certainly a record! I, and we, enjoyed it thoroughly. And another record letter from Dorothy (earlier) was equally enjoyed. This note is for both of you, to thank you for sharing your joys and sorrows with the "old-man." I say "note" because it will not be much more. I want to answer your questions, and send the almost due stipend.

We are working feverishly to get away by the latter part of March, to be in Seattle by April 1st. Two articles have to be written for Camera Craft before leaving. These are on contract by 50.00 each. Charis is "ghost writing" them so I can go on with my printing. They take time, though.

If I can get away - and I expect to - we will bring the exhibition. If something happens - and I hope not - we will ship it to be there by or before April 6th.

And now about a Carmel theater. I have not mixed in Carmel life for so long (four years!) that I don't know present day angels, I meant angles, but perhaps angels is apropos, problems, vacancies, nor do I know who to ask. Edward Kuster has a theater group in San Francisco - I am told. Why not have your director, Mr. Hector, write him direct. "Carmel" will get him for he still has a home here. He may have ideas. Also write Denny Watrous, concert management, Carmel - they too might have ideas. I tried to see Hazel and Dene but they are in San Jose most of the time.

As I remember Carmel, it's a difficult place for productions of any sort. Too much goes on for the "natives" to support, either with interest or money (tickets). And of course the tourist season is taken up with the Bach festivals to Mission pageants. I don't want to discourage you, selfishly I would love to have you here, but I have seen so many flops. For instance the Denny Watrous Gallery and their "evenings".

Lumbago sounds like the gay 90's. I don't know what its called now but something more expensive. Teeth too! Dear, dear! An extra five may help. Dorothy says that arguments rage at school over the function of art. How sad. What a commentary on this age. I am glad that I was born in a day when no such questions were ever raised. It was all very simple - art was something to be enjoyed.

Cigarettes! I have not had one since Xmas day or rather evening. Coffee? I have it on occasions, no longer in the morning. This turned out to be a record letter too.

Love and abrazoes to you both

Pops

Edward

March 17, 1939

Planning U.S. Camera Annual. Would like main feature to be 24 pages of Guggenheim work also 2500 to 4,000 words by you to accompany it. Though I can't offer what these pictures are worth, I can offer $500.00. I also feel this section will greatly help to promote your book ideas on the work. Sorry about my usual long delay in answering your letter. Willard Morgan and I are collecting all of your prints and will return them shortly.

Tom J. Maloney

Cole Boy -

This wire just came. I answered, accepting with reservations. I can select and make prints for reproduction within a few days, but the writing takes time, can't be hurried under too much pressure. We are already under contract for an article a month for "Camera Craft" and a book (text) by September.

I send this telegram to forewarn you of possibilities. I should have a letter, within a few days, of information, how soon the material must be in, etc. I can't turn this down if it's possible to do. We are just as anxious to keep our date as you are to have us. Have been working hard to get 'cleaned up'. I have already turned down an important contact from East who wanted to come here April 7, because I would "be in Seattle". However we will be up sooner or later, and still plan to be there by the 1st, expect to.

A grand long letter from Dorothy. We would love to go with you to Vancouver.

Neil is here building a settling tank and garage. He does not feel that he should go with us to Seattle.

March 23, 1939

Cole and Dorothy -

Don't have to have US Camera article until June - stop - but have sitting for Monday next - stop - Will take to Brett for developing - stop - Have to select 150 prints to send last for a private showing (details later) - stop - Charis working all night on 1st article - stop - Hope we will be on time - stop - Until soon and much love -

Dad

March 27, 1939

Cole and Dorothy

Charis worked all night on last article for "Camera Craft." Expects to finish today - then captions for Westways - In the mean time I am printing for Ansel several things for a book which will bring me (maybe) 70.00 - and developing sittings and packing. We are doing our best to leave Wednesday and more likely Thursday. Stop over night at Brett's for supplies. You can figure when we will arrive. I will not work on the way unless something super extraordinary. Just remember we don't drive fast.

If any last minute change will wire -

All love

Dad

April 19, 1939

Oregon Coast a disappoint after N. Calif. Too much inland,  Will send you a route. Expect to be in Carmel within a week.

Miss you and D

Love Dad

April 30, 1939

Cole and Dorothy

My sweets

Got to San Francisco to find that news of our marriage in "Elk", Mendocino County had leaked out into the Examiner. The story of the ceremony is too good to be true, but will have to be told someday. We had such a good time with you and with Dorothy's parents. And now to hard work. Neil still here. Brett and family fine. He has quit smoking and coffee. Better emulate your big brother. I'm going too.

Before you leave Charis will mark map for your coast trip.

Much love

Pops

May 8, 1939

Dear Pops,

"Congratulations" to you and Charis. It seems rather strange for me to congratulate my father on his marriage. How does one go about it? Oh well you know that I wish you both the best of luck and all that sort of stuff. I can hardly believe that Brett has stopped coffee and pipe both. I wonder how long it will last. I haven't smoked a cigarette since the day after you left April 14th. Is Neil still there, tell him to write me, then I'll know where to write to him. I certainly would appreciate a map whenever Charis has the time. How about those "Camera Craft." I received the check. Thanks. Well I'll be seeing you in a little over a month.

Love

Cole

May 30, 1939

Cole beloved -

Here is your stipend -

I enjoyed your newsy letter.

Mr and Mrs. [Zohmah] Jean Charlot are here on their way to New York so this is just a note between activities.

The 'big' article in U.S. Camera will not be out until autumn, but my work must be in by June - 50 prints and 4,000 word article. I'm busy! You will receive a copy, of course. You boys always first on my list. I'm sorry to say that L. took the books. Pressure was brought and she returned them express. I have never discussed the matter with Neil. It must have hurt him. Please forget that I ever told you. Please!

And now love and kisses to you and Dorothy

from    Pops

August 23, 1939

Cole Boy -

I did not have much of a visit with you boys in L.A., but it couldn't be helped. At least I will see you and Dorothy soon. How soon? We must plan so there will be no conflict of visitors with consequent lack of beds! Merle [Armitage - editor, entrepreneur and friend] and Ramiel [McGehee - dancer, designer and friend] will be here from the 1st to the 5th. The Sommers will arrive about the 18th. So let me know soon, when.

And what are your plans for the future? Or have you any? You were rather indefinite - And what of the car? My own plans will depend on bank procedures, of which your guess is as good as mine. If we can sell the H.L. place before the banks get busy we can save our own necks. If we do then a road has to be built at once. If we lose out then we go - somewhere!

I give you my status so you will know how much, or little, you can depend on me for the coming year. I wish that I could be more definite. If sales keep on the way they have been these last few weeks, all will be well. You can be sure that I will do all that I can to help you achieve your goal.

I keep busy. Endless printing, spotting, mounting. Article. A book for "Camera Craft" (text). A book - seems quite sure now - on Guggenheim work to be done by "U S Camera". An article on "photographic art" for next Encyclopedia Britannica. Exhibits: two on now - San Diego, Harry Champlin - and three more before the end of the year. My collection for Huntington Library. I have to keep in training!

How is boat going? Tell Neil to wire me in time for the launching. I have not developed negatives yet. Patience. Our trip back was enlivened by Erica, with Maudelle as leaven. We worked at the dunes a day while Erica ate and did other things to the white sand.

What a record letter! Addressed to Cole, it is written with love to all you sweet boys and girls.

September 10, 1939

Dear Pops,

I would have written sooner, but I have been waiting for a reply from my last letter to Mom, I wrote over a week ago air-mail and I haven't had a reply yet. I said that I was going to stay whether she sends me money [Flora sent Cole 20.00 each month for school] or not. Maybe she has disowned me, oh but what the hell! I'm free and doing what I want to, that's the only thing that matters really. Of course it won't be any too easy living on such a little but I think I can manage.

I am going to teach fencing at school, I don't know what the financial arrangements will be yet but I will get something, I also am going to teach a group of people outside of school, so I'll make all the profit. I'm not sure this deal is going through but there's a good chance of it, keep your fingers crossed.

With all my troubles, I don't think I've told you much about school, have I? Well I'm stage manager in other words I have control of the stage and the workshop. This means I don't have to do janitor work any more, thank God. We are presenting on the 2, 3, 4 of

October the play "Penny Wise". I'm taking the male lead. I am also dancing in one of William Butler Yeats' dance plays, "The Only Jealousy of Emer" so you can see I'm quite busy. Everybody is trying to discourage me about selling the car, but I can't see any other way out. I'll lose about $140.00. Well Pops, I sure hope you will write me soon, and let me know how things are going with you.

Much love
Cole

September 18, 1939
Dear 'Cole dear' -

Comment on "School is going to be tough": work doesn't hurt anyone, but the hysterical hopping around that I witnessed last year, does. Don't.

No use in commenting on the war, what can one say in a line, - or a book? What does anyone actually know? Oh yes we have all waxed eloquent. And get nowhere. One can only hope for an internal break in Germany. As for Stalin, I have never liked his looks - a shrewd, cruel, peasant. "Beware the man who rises to power from one suspender." Etc. Etc.

Ask Dorothy to send list of magazines she got, so she may be "billed". The books and magazines are part of the estate [Harry Leon Wilson's] and have to be accounted for no matter how small the amount.. Ramiel took a trunk full (I hardly saw him after he was in the books) and Jake Zeitlin [bookseller and friend] bought quite a bunch. He was here last week, the Sommers arrive today. Somehow I keep on working.

All love to Dorothy and Cole
Pops
I hope Dorothy gets her papers, soon!

September 27, 1939
Cole Boy -

I think your mistake was in asking if you could still expect a monthly check. This was rather negative. Rather you should have said that you were staying on regardless of help. Of course when I told you to "stall" for time, I did not want you to commit yourself one way or another, but put delay on the basis of school obligations, car sale, or what not. From now on you must take a positive stand - that is if you really wish to continue school. This you must decide for yourself. I have said enough - too much maybe. Cole, this is an

important moment in your life, one in which you have the greatest of opportunities, that of making a decision for yourself. In the making you will gain immeasurable strength. It does not matter whether or not you make a mistake, we all do. War, or not war, is actually immaterial. You escape neither yourself nor the facts of life, by trying to sail away from them. You may find that you are just as conspicuous and vulnerable on the high seas as in the front line trenches. Who is to say! Don't let anything I have said influence you, nor the council of any one else, nor the general hysteria - mass-thinking. Think for yourself, or better, feel for yourself. Allow something inside you to work, then act.

If you do decide to give up, go south, start doing your part on "Noah's Ark," then I will be with you at least in spirit. Your decision, either way, will affect your whole life. What a glorious responsibility, adventure! One is free only at the moment of decision; after comes routine, even reaction. Looking back, I can still feel the impact of such moments in my life. Whether you stay or leave, a new meaning has come into your life. Make the most of it.

The future belongs to those who do not indulge in mass-thinking.

End of the evening sermon -

God bless you

Pops

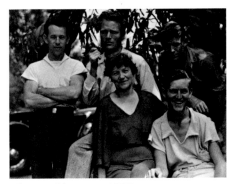

*Flora and her sons, 1937*

September 29, 1939

Cole dearest -

I was about to mail this letter, when yours with enclosure received. I may be wrong, but it looks very much like a war between parents. Flora evidently senses my usual opposition to hysteria. Of course she may be quite right ("war here in 6 months"). Only time will tell.

I will send you 25.00 a month - the best I can do - until Flora "comes through" because you are starving! Maybe it's time for you to put the screws on. I doubt if you will starve.

If you wish to hang on, sell your car, get a job on the side, anything to help yourself for the moment. But you will have to search your own inner-self for the answer. I have said enough. It will give you strength if you decide.

Flora must have inside information denied to even Roosevelt to make such positive statements ("war here in 6 months"). Perhaps she is psychic. "Must be well anyway in 4

months" means what?  Where do you go?  Just sail away?  Clearance papers for where?  One could write a page of questions.

But enough

Abrazos from

Pops

I, of course, will not answer Flora's note.  You can tell her that I have promised you 20.00 (which added to what I gave you makes 25.00).

*Also included in this envelope is another letter dated the same day*

September 27, 1939

Cole Boy -

I should be writing Dorothy.  She wrote me a record letter.  But this will be brief and a P.S. to my last letter.  Nothing has changed my mind since writing you; in fact I feel even more strongly that you should do nothing hasty.  A poll in Life magazine shows only 3% in favor of going into war with Allies.  Everything points to a long, slow war of blockage on the part of the Allies. Of course I'm only talking.  Everyone is.  Here is something else to think of: Neil just wrote that he was going to hunt for a job!  So what about all the help he was to get?

Of course a stage-career will not be of much use if you are in the war as a soldier, but I can't yet see that you will better yourself, nor anyone, by giving up, giving in to hysteria.  I hope that I'm not wrong -

I enclose check, as promised, for the next month.  Dorothy tells me that you took "about" 25 "Dials".  Let me know, because I will have to account for these.  Property belonging to the estate has nothing to do with us individually.

All my love to you both -

Dad

October 23, 1939

Dear Cole -

Your letter came while we were in S.F.  While there, Neil arrived with Hubert - later they stopped in Carmel for a two day visit.  Neil told me that when Flora knew that you were going to stay on she said that she would send you money.  This is all I know.  I will include with this note 25.00 for next month.  Very glad to hear of your school activities

and improved position. You may wind up owning the school.

I am in a rush period. Just got off Vancouver show (opens 24th) . Getting ready one for Hollywood - a retrospective of 200, from 1903 - 39. And winding up work on Encyclopedia Britannica - due Nov 1st. Hence this short answer which carries much love to Cole and Dorothy, from Pops

P.S. Two things you must do for me (or the first is a must, the second a request): 1st - List the magazines you got from the estate,   2nd - find out the history of the wooden - figures I photographed back of restaurant. I say the first is a must with good reason. The carelessness looks "irregular" even though I know it was not intentional.

from Pops      Dad      alias Edward

November 7, 1939

Cole Boy -

Always glad to get word from you, especially of your success as a mummer. Dorothy sings your praises. Good work! Wish I could have been there.

Glad you got in the magazine list. Will let you know results. If I used the word "irregular" in regard to the transaction, I must admit it sounds a bit irregular in writing. I did not mean to be nasty, but the estate matters have to be kept straight and up to date.

Shall I send you my dry-cleaning?

Glad Dorothy is blessed with a millionaire uncle -

I found the portfolio you (Dorothy) asked about. What shall I do with it?

And which of the proofs do you like best? I think they are numbered. All well here including Nicky [cat] who still has the "Haunts". Have a retrospective show of 198 pho-tographs, 1902 - 1939, on in Hollywood. Also Vancouver show is on until November 13. Hope Papa and Mama [Dorothy's parents] go see.

Love to two sweet children

Pops

November 22, 1939

Cole Boy -

Enclosed is stipend for December.   I thought from your letter that you could use now. But at least - enough lemons and lettuce to balance the beans - or whatever. The car is your problem - if you wish to go on short rations.

The proof you sent is my choice - so marked. I will pick another one and send on

with portfolio (not C.O.D.) I should confiscate it.

Hope you have a happy Thanksgiving Day. We will celebrate tomorrow. Brett and Jim will be here - in fact they just phoned from Monterey.

We too are having marvelous weather; clear and warm, almost hot.

No more now. Must clean house for guests.

Charis joins in happy day - and to Vancouver papa and mama too.

Love to Cole and Dorothy

Dad

December 16, 1939

Cole Boy -

Sending my section from O.S.C. Annual. Publisher gave me a number of bound sections.

Brett writes that you may be down for Xmas, that he sent some money, I would love to see you, but - be sure you can count on return fare. I will be broke very soon. To save the property [Wildcat Hill], I have to raise $1000.00 within a few days. This is final, and the only way out. But we will then have a clear title to property appraised at $6000.00, besides saving the amount already invested. To let it go and start over would cost more than $1000.00, so there is nothing else to do. You might as well be prepared for the worst. But you can be sure that I will continue your stipend as long as I can hold out. I don't expect to be "on my back" for long. But it is a hard blow all at once. I have had to pull all kinds of wires, here, there, everywhere!

Don't get discouraged -

Much love to you and Dorothy

Pops -

As soon as we get clear title, we will homestead and be protected forever.

Don't ever get mixed up with banks or less important sounding loan-sharks.

January 30, 1940

Cole Beloved -

I have not been - and am not now - in a writing mood. Charis has been quite sick with the chicken-pox - acquired from Erica! Grown ups get it in more severe form. Also, I have been cutting wood, which took all my time from dawn to dusk. The eucalyptus is all cut up and brought down here (in a wheel barrow!). A small pine likewise cut down and

then - up. I really had a swell vacation. You should feel my muscles. I'm trying - vainly - to catch up with you boys.

Enclosed is next stipend with extra 5.00 added for your 21th birthday. God bless you.

Bank is going ahead with plan to sale our acres to us. It's a slow process, which includes, rewriting water rights clause, surveying, etc.

I will be O.K. to pay the estate (for magazines) next month. Don't think that you are being discriminated against; all estate matters have to be on a cash and carry basis.

February 23, 1940

Cole Boy -

Just a few words of greeting - and the stipend - to the old man.

After Charis got clear of her pox, down came Leon [Charis's brother]. So we have had sad days - I remain well, thanks to the woodpile - which has discovered me long lost muscles - and gardening. Bank matters remain same - a verbal agreement. We are now concerned with getting the water rights settled to our satisfaction. The old house [Harry Leon Wilson's] is completely cleaned out except one room which Leon uses for $1.00 a month rent. The Salvation Army came today for the last of old mattresses, crutches, golf clubs, and unsaleable books. I wish you would let me know how much the magazines amount to. I will pay it to the estate, then you can pay me when you can. No - I have a better plan: send Charis check or [m/o] money order for amount, and I will send you my check, for equal amount return mail ( if you can't spare it). I can't go into a long explanation, but suffice to say that it is a matter of family pride on my part, and an object lesson to others.

We had a contractor up to look over the possibilities of a road, and made a bid: it will come up from the corner of the bridge on a cut all the way (no fill). The cost $350.00! Lucky we have arrangement with bank to use old road until they sell. But the sooner we can have it done the better. Hard shoveling. I prefer wood - cutting!

Brett will be here soon on his way to Sur for a month (he will have plenty of time to contemplate his navel). Neil may stop by for some carpenter work.

It certainly is too bad about Brett and Cicely [they were getting a divorce]. But I have nothing to say - what can one say? - except "too bad".

Send list of mag's with m/o - I want everything regular on our side of the fence. You can enclose in next letter to me without comments.

Guess this will be "thirty" for now

Much love and to D.

Dad

April 4, 1940

Cole Boy -

Sorry to have delayed the check this month.  Hope no great inconvenience resulted.

Many expenses have upset my balance.  Rains played havoc with our water supply. Dam and pipes filled up and filter broke.  We had no water for four days.  And more rain is falling.

No more now, except much love to you and Dorothy

Dad

April 10, 1940

Too bad that you have been sick so long, I did not realize from your letter that you were more than temporarily down and out.  Love and to Dorothy. It was kind of the Hermanns to let you hospitalize.

Dad

April 24, 1940

Dear Pops,

So sorry to have been so long in writing you this letter but as you know I have been very busy.  Well "Berkeley Square" made quite a hit, in fact people still come up to me, strangers, and tell me how much they enjoyed it.  I was quite pleased myself.  I am enclosing the write-up we got.  It was the first Cornish play that has been given any mention at all in the papers in a great many years.

How are things going with you Dad?  How is the property situation?

School is out June the 9th.  Dorothy and I will be leaving shortly after that.  We will probably spend a day or so with John [Short] in San Francisco.  I'm not sure yet I'll let you know more definitely later on.

I am dancing with the American Dance Theater - a Modern Dance Theater that Bonnie Bird organized.  We dance on five different nights. If it isn't one thing its ten.

Well Pops, I'll close now hoping to hear from you soon.  Dorothy sends her love.

Love

Cole

April 30, 1940

I hasten to send on stipend.

Very happy over your success in Berkeley Square.

Await your arrival with open arms.

Property matter the same.

Guess you have recovered or you would have commented -

This haste because I am getting exhibits for San Francisco Fair, New York Fair, and Fresno.

But the same old love and abrazos to you and Dorothy

Pops

May 3, 1940

Cole Boy -

Let me know return mail if you will need any more money for your return [from Cornish School] and if so, how much.

You know that Aunt Mazie had a stroke. I stopped over in L.A., but could not see her. She is said to be "improving". Right side is paralyzed. Besides the shock to all of us, money has to be raised for her care, and for Uncle Theodore's who will have to move.

I will have to contribute all that I can spare, but I don't want to neglect your absolute needs.

Had a marvelous experience flying to Chicago from San Francisco, returning to L.A. then up the coast to Monterey. All expenses paid.

See you soon.

Much love to C and D

Dad

May 22, 1940

Leaving for Chicago by plane Thurs - to judge exhibition. Return few days via L.A. May had a stroke. I am quite upset. Please write her a note at 1322, E - California Glendale -

Love, Dad

June 6, 1940

Cole Boy -

No news is good news from May.

I am teaching in Yosemite for a week starting June 19. Will have to leave here not later than the 17th. This comes pretty close to the time you will probably arrive. I hope you do not stop too long in S.F. Would not want to miss you!

Love to you and D.

Pops

Conclave of photographers under auspices of Ansel and "U.S. Camera."

June 27, 1940

Dear C and D -

I am wiring you $10.00 of your $25.00 to replenish your larder until we arrive. Should be in Carmel sometime Tues early or late.

So hasta la vista and love

from E and Dad

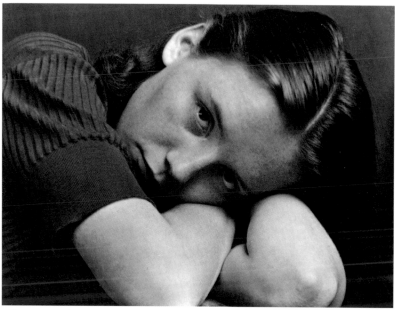

*Charis, 1934*                                    *Edward Weston*

*Civil Defense, 1942*                                                      *Edward Weston*

# 1940 - 1944

The year is 1940.  All the Westons are distracted by the imminent war. Cole and Dorothy marry and leave Cornish School for Southern California where Cole goes to work in the aviation industry.  Three years later Cole excitedly tells his father he and Dorothy are expecting their first child.  But they lose the baby because of the Rh factor.  Dorothy's diabetes also influences their desire to not try to have more children of their own but consider adopting Erica, Brett's daughter, (Brett is divorced).

By 1944 Brett, Neil and Chandler, enter the military.  Brett is drafted into the Army and is stationed in Missouri.  He first serves in the infantry, and several weeks later he is transferred to Signal Corps.  Chandler goes into the Navy, is stationed in San Diego, learns to be a torpedo expert, and is sent to Pearl Harbor.  Neil's migraine headaches prevent him from being drafted so he joins the Merchant Marines and goes to the South Seas to help with the transfer of supplies to war ships in the Pacific. Cole enlists in the Navy on May 31, 1944.  He is sent to radio school, then transfers to sheet metal school in Norman, Oklahoma in October of 1944.  Edward tends his Victory Garden and sends advice to his sons and outspoken letters to the Monterey newspaper.

Edward's strong feelings during the war included his opposition to the wholesale arrest, forced sale of property and transportation of Japanese citizens from the West Coast to desert concentration camps.  He wrote to the Monterey Peninsula Herald.

"To the Editor:

"Destroy Togo and Tojo with my blessings, but I protest with every ounce of decency in me the advertment you ran for the 'Monterey Bay Council on Japanese Relations, Inc.' How could you accept such a dastardly approach to race riots...and on the eve of the San

Francisco Peace Conference? The rooting out of disloyal Japanese is the work of our very efficient FBI, not that of a vigilante group.

"Who are the members of the 'council'? Why don't they come out in the open? They hide their real intent under a sop to the innocent by excepting 'Those (Japanese) in the uniform of the armed services...etc.' Phooey! Are we to exclude all Germans and Italians too?

"I think the 'Prayer of Peace' by St. Francis, printed alongside the 'council' excrement, should bring many a cynical laugh.

Yours - Edward Weston"

August 10, 1940

Dear Pops,

I haven't received an answer from my last letter, but I'm sure you are very busy, so I will just drop you a line. The biggest news of the day is that Dorothy and I are going to be married at last. We can't be married for at least five weeks, because I am going to school to learn the aviation trade. I went down to see Beatrice Griffith at the N.Y.A. offices. I wanted to see if I couldn't get a job teaching theater at one of the many recreational outposts. She said she could probably get me a job doing that, but she said what good will it do you in a month or two when the draft bill goes through. So she signed me up on the aviation project. We go to school for five weeks which we are paid $18.00 a month by the government, then we are put in the airplane factories at $100.00 a month for a starter. I don't think this is such a bad idea for these times, do you? I finally convinced Neil to do the same, so we will go to school together and work together. I have already been accepted and have had my physical exam, which I passed 100%. Neil hasn't received his card yet because he started later than I did.

Both Dorothy and I have made some swell contacts since we have been down here, but they won't do me much good until this damn war is over. After we are married we want to take a trip up and see you, sort of a honeymoon, I guess. I sure wish you could come down to our wedding. David (Hagemeyer) might drive down in his new car, maybe you could come with him. Well anyway, we will see you soon and have some swell times together.

Much love to all
Love
Cole

October 26, 1940

Dear Pops,

It's been so long since I've written anybody that I have practically forgotten how to write. As you already know Neil and I are working at Lockheed six days a week which nets us over one hundred a month, which isn't bad for a starter. We aren't in the same depts. Neil is in #10 building bomber noses, I am in #12 riveting wing tips together. I am getting on swell, already I have been advanced, not in pay, but in position. I'm a full fledged riveter, it usually takes a couple of months before they will let a beginner rivet right on the skin itself. I may be put in charge of a jig very soon which would be another advancement which should lead to better pay soon. We went down to the draft board yesterday to get our numbers, mine is 1458, Neil's is 1457. I don't remember what Brett's or Chan's are.

I see that Dorothy has told you about our house, it really is swell to be master of a household, paying for everything out of the sweat from your brow. I hope I won't always have to pay for it by working in an aircraft factory. Now that I am not around a theater I get the longing more than ever. I went to a reading of "You Can't Take It With You" - which is being cast by the Lockheed Theater Workshop, a small group out of the 13,000 employees at Lockheed who are interested in theater, so they started a group. The play had already been cast, but I read anyway. The director's eyes lit up when I mentioned Cornish and he said that I would be a great use to the group. After the reading he said that my interpretation was so much better than the others that it stood out too much. In other words, it over balanced the rest of the cast. And as they already had the play cast, he didn't like to change it so late, so I guess I won't be in this play, maybe I'll try out for the next. Well Pops, I guess this is about all for now. I do hope you will come down very soon, we have plenty of room, only ten minutes from Hollywood and all that. What do you do with a cat that craps in the clean laundry basket???

Much love

Cole

P.S. Bosum is the cat's name.

*Same letter continued by Dorothy*

Dear Edward,

Well, here we are - renting a darling house out in North Hollywood. We have a large, enclosed porch running the length of the house, so when you and Charis come, you can stay here with plenty of room to spare.

We were married by a Justice of the Peace in Glendale, it was all over in about 5 min-utes - talk about "stream-lined"!!! We moved in here the next day, and having a grand land lord and land lady, the place is practically fully furnished. The house has been built by the husband from a little one room shack moved over from Glendale 30 years ago.

We are in a lot about 130' by 340', lots of trees, a garage, automatic hot water heater and all the latest conveniences, all for $25 a month. I think we were exceedingly lucky to find such a place, as any rentals are hard to locate these days. Then there is the added fact of that we are only a 15 minute drive from Lockheed.

Thank you for your sweet note, and please come down and see us soon.

Mother's (by the way, her name is Elise not Ellie) and Dad's address is 3173 West 11th Ave Vancouver B.C. Cole sends his love - apologizing for not writing, but he works 6 days a

week and has so little time, as he's pretty tired in the evenings, anyway, he wanted me to tell you that he will be writing soon.

Much love to "Pops" and Charis too

Dorothy

P.S. IT'S RAINING!!!!!

January 17, 1941

Dear Pops,

This is the first letter I have written in over a month and I'm very ashamed of myself. Every day I would come home from work saying to myself that I must write. But by the time dinner was over, I would be so tired that all I wanted to do was go to bed. On Sundays, my one day off, we would go down and help Brett on his house, so consequently I would never get my letters written. But tonight I swore that I wouldn't go to bed until I had written at least you.

Things have been going on pretty much as usual, the only really good news is that I am not working with Kenny anymore, you know the fellow I couldn't get along with at the plant. I am in charge of the jig now and have a fellow working under me.

I suppose you have heard about this by now, I mean about Ansel photographing Dorothy and me. Anyway, he was sent to L.A. to photograph the aircraft industry for the March issue of "Fortune". Well, anyway, he decided to photograph the typical Lockheed worker at home and at play, so we were chosen to be the model family after Brett suggested it to him. He took pictures of us cooking dinner, then eating and then a cozy after dinner circle in which Dorothy, Bosum and I were the circle. After that he wanted to see some Lockheed night life, so we drove up to a joint "Don Smiths" by name and had a few beers while we waited for the manager to appear so we could get his permission to take pictures, which when he arrived he readily consented to although he was a little dubious about his patrons in case "man wasn't with wife" sort of thing. Well we preceded to ask people if they were from Lockheed and finally a couple of people were bold enough to admit it and also to be photographed. Then he took shots of us dancing and so forth. After that we went to the bowling alleys where he photographed the top Lockheed bowlers and also us watching them, by that time it was around twelve, so we went home. Brett was with us acting as flash bulb carrier and general handy man or should I say photographer's helper. Well anyway, we had a swell time and a big kick in the lime light, of course this might not get any further to getting into "Fortune" than the waste basket but it was good experience.

By the way, I will send you a dollar next week on the four we owe you, thanks for

being so patient. God the life of an aircraft worker is boring when I think of the swell times I had at Cornish and when I wasn't a wage slave, oh well, I guess there are things that could be worse.

Well Pops, I've just about worn my hand out so I guess I'll stop now although I haven't said much. How about a letter soon. What is David Hagemeyer's address, could you find out? Thanks

Much love

Cole and me too

P.S. I was very sorry to hear about Jim, why is it that such intelligent, generous, people like Jim seem to go first.

March 10, 1941

Dear Pops,

I have been holding off writing you until I had some worth while news to write about and also until I could send you a dollar. We have been  pretty short lately.  We are helping Brett out by buying his bicycle from him  $3.00 a week for seven weeks.  It at least makes him feel not quite so broke, so consequently we have been pretty short, also a tremendous dentist bill which we pay $2.00 a week probably for the rest of our lives.

Well the first and biggest news is that I am in Class 3 deferred in the draft.  I guess because I am married and am working in a big industry.  I am no longer a riveter, thank God!!! after 5 months of it I was just about going nuts.  Last week I was put on pick-up, that means I final out the wing tips by taking

*Cole*                    *P. A. Dearborn*

out all the bad rivets, dings, and putting in skims etc in other words I made them so they can be put on the plane.  It's swell work!  I work by myself, can sit down or stand up when-ever I like and go to  any phase of the pick-up at anytime I like.  The work is always varied. When I come home from work now I'm no longer half-dead or have a headache like I used to.  I'm quite contented now, at least as much I can to be working where I do.

Be sure and look in the March issue of Fortune, you will see the pictures Ansel took, two of them anyway and a stinking article on page 163 which will probably get me canned

if anybody reads it, oh well what the Hell?  [The only copy of this article I could find had the pictures cut out.  The article follows:]

"The kind of employee you do see in all the factories, young and a little wide-eyed, is much like Cole Weston, who is now a riveter at Lockheed.  Cole lives with his wife in a rented two-room-kitchen-and bath frame cottage back of their landlady's house in North Hollywood,  eight miles from the factory in Burbank.  He is twenty-two, fair, straight-nosed, and ingenuous, a typical young Anglo-Saxon American worker.  His background - high school and then dramatic-school training in Seattle - does not set him apart from his fellows; Cole merely believed that he could get ahead better in the theater than in a filling station.  Six months ago, with the draft looming ahead, he decided that he would rather go to work in an aircraft factory than march up and down in the fog at Camp Ord.  Neither he nor his twenty-four year-old brother, Neil, is especially enthusiastic about building planes for the 'emergency.'  'It's a job,' they say.

"Cole and his brother came to Los Angeles and entered a four-week NYA course in riveting at the Santa Monica Technical High School.  Cole thinks that the NYA quickie courses are the best training for the beginner, besides, the NYA pays you $18.00 a month.  Both Westons were quick at riveting and finished the course in two and a half weeks.  They waited patiently for Douglas to hire them, for the NYA at Santa Monica uses instructors supplied by Douglas and feels, logically, that its graduates will get along better there.  But after two more weeks on the NYA project they got tired of waiting and hired out at Lockheed.

"The Westons have been there five months.  Neil first riveted small, simple parts of the bomber frame; now he rivets the frames for the bomber noses on the night shift and will soon be classified as a framer, which is a step upward.  Cole began as a helper installing conduits; he was then shifted to helping the lead man in his department with riveting.  Now he is in wing-tip assembly, in charge of riveting for his jig: he teaches another man to rivet while he bucks (because on wing tips bucking is harder than riveting).

"Both boys have had one raise, the beginner's raise after two months, as required by the Machinists' Association contract, and they are due for another contract raise in another month.  Present wage: 57 cents an hour.   With eight hours a week overtime, that comes to $29.64 a week for Cole; and with a six-cent-an-hour bonus on night shift work, to $32.52 for Neil.  Neither Weston belongs to the union; it isn't that either of them has anti-union prejudices or that they prefer U.A.W. -C.I.O. to the Machinists - they are just not interest-ed.  Cole and his wife do not play around much with other Lockheed people after hours or on weekends.  They don't know many.  The place is too big, says Cole, for you to know

anybody except the guy who works alongside you and confides the secrets of his private life above the noise of the rivet guns.

"Putting a veneer of skill on the beginner such as the unskilled Westons acquired taxed the ingenuity of the country's vocational schools. Before the emergency, vocational training in public and private commercial schools was based on teaching the principle of craftsmanship - would-be machinists spent from two to five years learning the rudiments of all-round, high-skill metalwork. Only the gyp commercials (and these are many) claimed that students could be made into mechanics overnight. But today the short course, engineered for a particular factory, is the back-bone of the emergency training program and a major project of the government's labor-mobilization program under the direction of Sidney Hillman."

We are trying to start a Theater group, it will be composed of just Cornish graduates, will probably be called the "Cornish Players". At first it will merely be a avocation until it (we) can make something out of it. It will all be on a co-operative basis with each one doing what he or she is best fitted to. Miss Cornish was very enthusiastic about idea, and offered her whole hearted support. Something might come of it and yet again might not. Heres hoping anyway. Bosum is sitting on the window ledge winking at me. He is fine and quite a tom too.

Well Pops I hope we will be able to see you soon and Happy Birthday now in case I forget later.

>Much love
>Cole
>Dorothy sends her love

March 4, 1939

Dear Pops,

Surprise !!!! I bet you had given up the idea that you would ever hear from me again, well, I am turning over a new leaf as far as my correspondence is concerned, I promise I will write more often.

As you probably already know I have a new job, Instructor at the Frank Wiggins Trade School. I received my teaching credentials last Monday, so now I am on the payroll of the Board of Education, which by the way, is a very substantial increase over what I was making at Lockheed. $85.00 per week (5 days) not bad??? I feel like a white collar man, only working 5 days after working 6 and 7 days for the past 2 1/2 years. It's great!! Well

with all my wealth, Dorothy and I decided to buy a home, we payed the deposit on the down payment Monday and today the owner signed the contract, so the house is practically ours, if we can raise the down payment $1200. Which we can, if everything goes alright. We have 130 days to do it in. It's a swell house, 2 bedrooms, one for Erica, 2 baths, living room, kitchen, den, and garage. Two stories.

As I am a lousy artist the only way you will be able to see it is by coming down, how about it, the train maybe????? Brett is being swell to us, letting us live here until we can move into our place. We moved our whole family down including Monte[cat] and the two bucks, Milly and Pressy [rabbits].

I tried to get Neil a job as an instructor at the school, but they wouldn't take the chance, because of his draft classification.

Well Pops, this is a lousy letter, but it isn't too bad for a man who hasn't written in 6 months. I will try and do better next time.

Much love

Cole

May 1, 1943

Dear Pops,

I just had a swell swim in a very rough and angry ocean after a very hard days work, which for some reason has put me in a letter writing mood. These moments seems to be getting farther and farther apart, remember I used to be a steady corresponder while at Cornish, now I am terrible.

We had such a perfect time while visiting you, the only trouble about those shorts visits are, that it only makes the yearning to see you more often, greater. We had such an important talk up on the flat, at least it was important to me. It made so many things more clear. It seemed to me, that we came to a much closer understanding of each other than we have in the past, an understanding which is so more than father talking to son. I hope you understand what I am trying to say, it's something I've never put down on paper before so I can't express it very

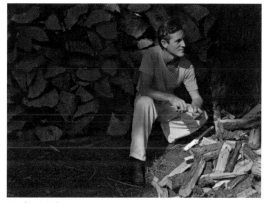

*Cole, 1942*

well.

I am enclosing some proofs and I do mean proofs of the pictures I took last time and the time before. They were made from some out-dated paper that Brett gave me. I marked the one on the back that I like, do you? They aren't too badly timed considering I capped them, but what a lot movement in the background. Remember Bo-sum "purty kitty?" I will do some serious printing on my own things before long and will send them to you to be torn apart O.K.?

We are all working like mad on the boat as it will be launched on the 28th of this month. I'm on a six day week now, damn it, oh well, it was a vacation while it lasted. $96.00 a week now. Remember Pappy, if at any time there is anything you want and yet you feel you shouldn't buy it, please let me know as I want to feel that I have repaid you for being such a marvelous father to me, for giving me someone to be so proud of, you.

Well Dad, Dorothy and I are going to take in a show tonight as it is Saturday, so we have to go if we want to get home early, so that we will be able to put a full days work in on the boat.

All my love

Cole

P.S. Dorothy sends her love.

Dear Edward.

This is just a sort of P.S. to Cole's letter, I wanted to say that I, too, gained a lot from our talk up on the "flat". Usually I feel that the boys would rather talk to "Pops" alone as they see him so seldom, but I'm glad that this time I was along too as I believe it's the first time we have ever discussed in quite such a manner. Thank you!

All my love

Dorothy

May 8, 1943

Cole Boy

Your letter, full of love and understanding, was a continuation of our talk up on "the flat" - a talk which meant a great deal to me too. I am going to continue these talks via mail (or I intend to) and so doing may help to clarify much in my own mind. Please never think of them as lectures or "sermons on the flat". And they will be written to all of you, no matter who receives the envelope. The distribution will be up to you-all, which includes

Dorothy who has a big chunk of my heart, and her own place at the round-table.

A few comments on proofs: You have figured out what I could have told you that you can't make a time exposure which includes the quickest possible cap exposure - of a standing figure supported: Charis pleased with Bosum: I like the one of me Cole likes (of course air Raid brand is far too important for it's place in the corner). The roof of the house that Neil built is well seen. I think you almost got something of Tiger. Send along your serious printing "to be torn apart". Show the same prints to Brett for criticism, and see how we check.

Here is the check afore mentioned which I want to go on your down payment. It is from the ghost of your grandfather [Edward Burbank Weston]. Keep the figures of these checks in the circle of you boys, please.

Large abrazo for; "if at any time there is anything you want please let me know." If I tried to answer this I might become maudlin!

Your Father sends love to his dutiful
Children and grandchildren.

May 8, 1943
To Flora
Hoping that she is surrounded by innumerable sons, daughters, grand children on Mother's Day.

To all, my love -
Edward
Dad
Pops
Papacito
G.P.

May 15, 1943
Dear Pops,
Thanks so much for the swell letter and the $25.00, we put it down on the house which makes $1100.00, so far that we have put into it, next check I will put $300.00 more and the house will be 1/3 ours. We are having a little trouble over getting the present tenants out but I think it will come out alright.

I have found myself very restless lately, even with the new job, house, etc. I haven't

had any way to release my "pent up emotions"after having a counsel with myself, I decided I had to get into theater work again or else I would do something drastic such as quit my job and join the Army. I went to a rehearsal of "The Eve of St. Mark" which the Lockheed group is doing. By luck a fellow dropped out, because his part was too small, so I snatched it up, so now I go from Santa Monica to work in L.A., after work I drive to Mom's, have dinner, then go to rehearsal in Hollywood, after which I drive back to Santa Monica. It makes a long day but it's worth it. At least now I am going towards my goal, war or no war. It makes life seem less futile. Maybe this is the wrong attitude. Should one put his own life aside and devote his entire time to the war, and thus lose sight of his objectives, or is it possible to shut yourself off from the madness and choose which has descended on to the world, for a few hours a day, in which to find a welcome relief. I think it is not only possible, but an absolute necessity, in order to enable us to look into this war with a clear understanding of what and why we are fighting.

Well Pops, this letter isn't so hot, my hand never puts on paper what I want to say, at least not clearly. We are looking forward to that visit when?????

All my love
Cole

May 24, 1943
Dear Cole -
The question you posit in re the artist and his activities in war time has already been answered by you; you had to return to your creative expression. And in like manner Neil went on with his, so did Brett, so did I. Chan? I've lost all material contact with him, but this letter is to him too. Despite war, even because of it, the biological urge goes on, and so does the creative urge - perhaps in keenly intensified form. Whether or not your work can't help being influenced indirectly; so pay no attention to those who say "Ivory tower" just answer "Ivory Soap to you." If you wish to do propaganda for or against "-ism-" fine; but don't imagine that the propaganda isn't there, however it may be hidden. If the law enforcing agents could only understand the significance of some music they would ban it, burn it. Communism might be seen in Bach or Fascism in Wagner.

*Edward*          *Richard Miller*

I am not trying to label - I have been too often labeled.  If you are not burning your candle at both ends with St. Mark's help, then accept my blessing.  Your war effort should be helped by your creative activities, while damning the latter can lead to psychic chaos.  I am using "you" in the plural, as usual.

There is so much that I have wanted to write "you - all".  It can no longer be father to son stuff, but man to man.  As a parent I have painful memories of my failings - I guess every parent must have like pangs.  I can only hope that my sins have been those of omission rather than commission.  I have seen too many parents living their children's lives for them, actually preventing them from making mistakes and so stunting growth.  Of course these parents love their children, but with a Shylock's love, expecting, demanding return.  I am making excuses for myself, of course; for I have gone the other extreme in wanting you to have your own experiences, live and learn from them.  Maybe in not wanting to preach, I have not talked enough.  Question, question, question - always two sides and which is the right answer.  I well remember one wrong answer sent to Cole in Seattle.  I insisted that this time there would be no A.A.F.  That we would be in the war, yes, but I visualized machine vs machine with no use for vast armies.  In this case I feel that my bad judgement did no harm for I'm sure that you would not have avoided anything, gotten anywhere in the Spindrift.  But you did bring home something pretty sweet and fine from Seattle.

The War; how can I even start on such a subject!  You know that I was bitterly opposed to the last war - that I thought it was all caused by the "vested interests" made billions, but they alone were no more the cause than poor old stuffy Hoover was the cause of the depression.  I taught you to hate war, and I still hate it, and who doesn't?  Yet you find me, of all persons, in the army, literally and eagerly.  A lot to explain, we will have to skip years; I'm not going to be a historian.  I would have to begin almost thirty years ago, delve into how we won the war and lost the peace (through the same kind of a gang that is trying to gain control now), how we lapsed into a post war cynicism encouraged by the Germans and Japs - and don't think that I am being naive.  Every man was for himself, every nation too.  Stock speculation a symptom; make money at the expense of the other fellow.  Everyone hoped to be a capitalist, the bootblack, even the artist.  Then Crash.  The best thing that could have happened to us; our fault, me too for my cynical pose, or better shield.  Crash - and we were in a revolution, a bloodless one; the Roosevelt Revolution.  And the reason that Capitalists hate Roosevelt is because he saved their woolly hides.

The reason that I am in this war: [Edward was a member of the Ground Observer Corps, U.S. Army Forces, IV Fighter Command, Aircraft Warning Service]  It is a continuation of the revolution.  The moment we declared war we were in it.  The counter revolutionists, all the old isolationists, the Roosevelt haters, did all they could to keep us out - for

the sake of their petty pocketbooks.  But, thank God for a Pearl Harbor which awakened us, we are in it - and because it's our only way out.  Feeling this way, I was, and am, for the draft; it had to be.  But I have a parent's qualms, and I have hopes that you will be spared, whether you remain on home front - where you are in greatest danger - or whether you go to battle front. I might even pray for you in some abstract sort of way, and to some pagan sort of God.  I sincerely wish that I could go in your place; or in some younger person's place. Not that I am weary of life, on the contrary I'm pretty much alive; but I do think that I have been granted a full, rich life, that I have had more than my share, can be considered "expendable".  Unfortunately for the Armed forces I can probably be of much more value on the Victory garden and O.P. front.  (I will have my service arm-band award this week)

I have used the word "revolution" several times; by it I mean our own particular brand of quick change which fortunately, thanks to a wise statesman and his supporters, was bloodless.  Roosevelt did not go far enough for some hot heads like myself; for example how we should have taken over the banks; give us back our money, the money our ancestors earned; but he was wise in not moving so fast.

I seem to have gotten myself well wound up, and in doing so tried to touch on too many subjects. I think we can let our armed forces, and our commander-in-chief, Winnie, Stalin and Allies in general, fight this war.  All the little arm-chair strategists irritate me, though I admit it's fun to speculate.  But we at home must concentrate every ounce of energy to wit to guarding our liberties and winning the peace.  We must raise our voices and sharpen our finger-nails against the Ham Fishe's, the McCormick's, the Martin Dies' and the John L. Lewis' who would sell us out to serve their ends and the Devil.  I would add Eddie Rickenbacker; he and Lewis are especially dangerous because their real meaning is disguised, illy placed, behind a righteous cloak - Lewis that of Labor, Rickenbacker that of the Hero.  I would not be surprised to find Lewis in the pay of "America First" or some KKK group.  Steff [Lincoln Steffens] warned against Lewis years ago.

Enough for today

Yr. devoted Dad

P.S.  We are leading up to the "little fellow" (in World War I he was called "The Masses" - and suppressed) and why the artist must be on his side; just because the artist is an anarchist at heart.  Perhaps the subject is beyond me.

*Because all letters to the "boys" are for all, this letter is included.*

June 4, 1943

Dear Brett and -

In conversation thoughts can be presented more clearly than in writing: accent, intonation, discussion of moot points on the spot, all keep to clarify. But in writing the choice is in words, and words have shadings which bother even experienced writers. So what, for the poor layman!

I am thinking of course of my last letter, especially that part on the draft, wondering if I made my stand clear. Leon's case is close and real to me. I can't agree with his position, for I am sure he does so from his heart. After all we are living in a democracy and must fight for the rights of those who disagree with us, unless they are obviously enemy agents. One of my faults, best known to myself, is intolerance; so I bend over backward to be tolerant. I think one reason for my personal brand of intolerance is impatience with those who differ, hence stand in my way: impatience plus inability to answer adroitly. This is all obviously defensive, and a little off the track. Re the draft again. I think it has one glaring fault in that it denies a conscience to all who do not belong to a religious group. The questionnaire does not give any space in which a C.O. might register his opinion, or protest. Surely there are as many honest persons outside church doors as in.

I am furious today over Fulton Lewis' broadcast of yesterday and his "5th Freedom". I have welling up in me a hopeless rage at one who in such a critical time would attempt to split this country wide open - prepare us to lose the peace. If my theme song is on "losing the peace", I sing it thinking of you, and your generation. It is not likely I will be here for the next war which we can expect if the team of Lewis and Lewis (John L. and Fulton) are successful in their obscene alliance.

But I believe that this letter was to be on the "little people," and I am avoiding the subject. The artist is invariably an anarchist, while the people, the masses, are inevitably communists - for reasons of self protection, from sheer fear of walking alone. You will understand I am not speaking of political anarchism or communism. Now as a good anarchist of many years standing I am on the side of the underdog - the little people - as against their leaders, those who rose from one suspender to become Steel Barons, Coal Kings (how we Americans love titles!), rose from the masses, through craft or cruelty, to betray them. Despite my stand, I believe in classes, think we will have them until we go to heaven no matter what "ism" is in power. But the "ruling" class, upper class, leaders, or what you must come from those who have risen through intellectual ability - spiritually not materially. And our American financiers, businessmen, are, almost to a man, money grubbers from

the ranks, hence unfit to lead. Note the failure of our "business" administrations.

So we have in the U.S. - not to mention other nations, but particularly here - an aristocracy based on money instead of a spiritual aristocracy. I wish that I could have written "had" - but not yet, though we have gone a long ways these last ten years. How much we have lost of our gains in the last 10 days, through John L. Lewis, remains to be seen. He is one of the most evil men of our times; he is anti-labor, not pro. He is Hell bent on destroying labor, and Roosevelt.

I have a fixation which is depressing: that "Labor" and "Capital" will never be reconciled, for the very reason that the capitalists all rose from labor status; knowing how they fought and bought their way, they mistrust others in the class they came from and belong to.

Don't think that I have any objections to men rising out of their "class", going as far as they can in personal growth: on the contrary I believe the only hope for the people, the little ones, is through the growth of individuals. But somehow the emphasis on material ends must be changed: I don't know how unless through some great leader who can give us a new destiny. Certainly it can't be done with laws. The more laws, the more lawbreakers - and endless chain of profit only to the lawyer. American's classic example of the break down of law is of course prohibition. (FDR has been, is, a great leader: so I should have said "greater").

The kind of people who make up a race is of far more importance than the kind of government (laws) they have. And people vary in kind as do cows and tigers. Very wisely Stalin does not want a strong German brand of Germanism with a new name and face. It takes on the color of the race which has adopted them; and laws are of importance only in their interpretation.

Letters came which needed immediate answer, gophers had to be trapped and the Victory garden sprayed for mildew. So this family letter had to wait. The now Bawdy-Bodie insists on sitting in my lap. She is full of purrs and babies. Once more I will have to be sexton. The tenuous thread of this letter - if indeed it had any - is broken. I will try to pick it up and splice into next - soon.

All love ever

Dad

June 21, 1943

Dear Dorothy - [also written to Cole]

My next - , and delayed letter, was, and is, to be to Neil - just to spread them around. But you ask me about zoot suiters. I feel very strongly on the subject; feel something sinister and treasonable in (America) rather natural that I wrote "America" unintentionally the background. I saw the quotations in Time magazine for L.A. Times and Hearst Yellow - two of the vilest sheets in America. My blood boiled. Hitler started his youth movement with just such riots. I believe an attempt is being made to divide us, divide and rule, - or conquer. Someone on top started this rioting, saw a chance and used it well. But the above is all speculation; of this I am sure - that Mob rule is no part of a democracy, that even though the Marines, Sailors, Soldiers had good reason, they did not have the right to take the law into their own hands and inflict punishment. In a democracy we have courts of law, and every time we have mob violence, lynching or beatings, we are admitting that democracy has failed.

I once had occasion to write the late Governor Ralph of California on the subject of mob rule: told him that he was responsible for lynching in San Jose (he delayed calling out militia in time to stop).

Finally if a people thinks that justice has broken down they should throw out of office those who have failed, not break their own laws by resorting to violence.
- Your question could start a chapter
Love and to yr old man - E -

November 5, 1943

Dear Pops,

At last an evening at home, so I will write you about all the news for the past couple of months. First and by far the most important news is, that on June 7 or there about you will be a grandfather all over again. It all happened on our last visit to you. Surprised???? We are both happy about it, and are looking forward to a new experience. How about some good pointers on "the prospective father" or what to do about morning sickness, which by the way Dorothy has not experienced.

Next on the list is, that tonight I have decided to go back to the plant, for several reasons. 1. Deferment possibilities are much better in the shop. 2. I need a change and 3. as an instructor I haven't had any chances of bettering myself, while in the shop there are always higher positions to strive for.

I guess you don't know about my Coast Guard activities. Well for the last couple of

months I have been in the Coast Guard Aux. which entails, one class session and one all night guard duty on the pier a week.   1800 to 0500.  The auxiliary is a complete civilian organization, sort of like your post watches.  But for the past 3 weeks I have been going to school 4 nights a week, in order to get into the Coast Guard Temporary Reserve.  I will be sworn in, in a couple of weeks, will be issued $150.00 worth of uniforms and will then be a full fledged Coast Guardsman one night a week.  We will serve on patrol boats and so forth.  Our classes were on "Guns" "Explosives" "Rules of the Road" "Sabotage" and so forth.  Very interesting.  Well that's about all the news down our way Dad.  Oh yes, we now have 4 does, a buck, and 5 babies, you know rabbits.  Two of the does are expecting. My deferment was up October 5th, haven't heard yet, will let you know.  Have to eat now, write soon.

  Love
  Cole

November 6, 1943

Darling Children -

The news that I am a prospective grandfather again, quite overwhelms me.  When your letter came I felt something important in its contents, and hesitated before opening, actually, this is by the way of speaking, for I am not the kind who delays, maybe for days the opening of a letter - fearing the contents.  I usually can't wait, open the letter of the day before I get back to my desk.

 I think the news is great.  I think the news is great.  I approve.  I wish that I could accept your invitation to give you pointers on "the prospective father".  You compliment me.  I have a feeling that you two will have the answers when the time comes.  You know how I feel about well meaning meddlers, those who would prevent us from the great experience of making mistakes.  However, we will have a good exchange of ideas upon the flat one fine day.  As to morning sickness, I've not had it.  Having a child is the normal procedure; those who don't have one are abnormal - and probably pay nature in some way, physically or mentally.

 Your Coast Guard activities sound exciting.  Come up and let me photograph your uniform, - or - 'forms.  After me, of course, you will be the first member of our family to be in the Armed Forces.  Or am I wrong?

 Though we don't have any regular watch, we are not on continuous alert.  Charis was called up on a practice alert last week.  I have "owed" you - all a letter for some time.  Many good excuses for not writing, such as cutting winter wood, Victory garden, winter planting,

Leon here, editing my Mexican Day Book and quite a few visitors - not house guests.

I await news of your job change, your military status, and of Brett's, and of Chan's (does anyone know anything about him?). And I would like to have Tuttles address; have a baby portrait for them.

We are going to see Draper dance Sunday.

It is a good time in your lives to read the books of Charles Fort. He is one of America's great - as a thinker and a writer. Superb writing. I am rereading. He is not against science, he is against dogmatic science, or dogmatic anything ... I suggest "The Book of the Damned" first, because in the first chapter he states his approach to life.

"That Firmly to believe is to impede development.
That only temporarily to accept is to facilitate"
Charles Fort —

But I should not try to pick out single lines or thoughts to indicate his philosophy. Fort would object.

Great hugs and every thing good
from    Dad
Charis thought the news great too -

*This letter from Neil tells about an incident involving he and his two brothers, Brett and Cole.*

Dear Dad -

Thanks for the shoes. They are a little too narrow for me so will let Cole and Brett fight over them.

Last Sunday we went on a last photographing trip into the Mojave Desert. While photographing the main S.P. railroad tracks, we were arrested by a State Highway Patrolman and taken to Mojave. Luckily Brett had already packed away his camera and holders with precious images on them. Poor Cole had to open his holders and ruin his. We talked fast and furious to keep them from searching the car. Finally we were turned loose with the promise that we would be investigated by the F.B.I. We mentioned that our Dad was a world famous photographer which impressed the Sheriff greatly. In fact he said at first we could let you

*Cole, Dorothy and Brett*

develop the pictures and then send him prints to see if they were subversive. There is lots more to this tale but it gets too complicated to write about.

After we were free we went on into the back hills of Mojave on the Weldon road. Took some beautiful pictures, and found a pair of shoes which I am mailing you with Christmas greetings. Hope you can use them. I found them at an abandoned mine. Speaking of Christmas, I wish to god you would come down for a little while. Not only Christmas but any time. If I get drafted I will make every effort to see you first. I will join the Coast Guard before they can get me in the Army. I think I am more fit for that.

I said my deferment was up the 13th but it is the 16th. Won't be long now. I am glad you joined the "Air Corps" and its great to hear that you are still having sittings. The boat is coming along very swell. Toilet, chart table, bunk and sail locker all in and more on the way. If I am deferred again I may launch her.

Well, Dad this letter is becoming endless so will close before you fall asleep.

Much love

Neil

February 13, 1944

Dear Pops,

Having just completed a strenuous day in the Victory garden, it being Sunday, I find that I have time to answer your swell birthday letter before dinner.

I have been working hard at the plant but I find it harder each day to keep up my interest in a job which I am sick and tired of, after more than three years, almost three and a half. Also the long drive of 25 miles each way, taking two hours out of every day bucking heavy traffic. Well I guess I am better off than lots of fellows.

*Brett*

Brett phoned today all about his new job or should I say transfer, I am certainly glad for him that he is out of that hell hole. We have had two swell week-ends with him, sailing, etc. It gives me a very strange feeling to think of him being so far away, the canyon seems lonely with out him. My deferment is

up the end of this month, maybe I will be next.

Dorothy is getting larger and larger, I mean Conrad, if it's a boy. So far she hadn't been sick, she looks like the picture of motherhood.

Chan phoned the other night about the white slip for the Ford, he said he would be out West in a couple of months, of course this is an old story. By the way our telephone number is SM 4-2091 just in case you might need to phone us. I am in Coast Guard Temporary Reserve now. I spent last Saturday night 2400 - 0400 marching up and down on "Standard Oils" El Sagundo pier with a 45 caliber sub-machine gun tucked under my arm. It's one of the main outlets for 100 octane gasoline, also oil for the lamps of China or where ever it goes.

As it is impossible for us to travel with Dorothy in her condition, would it be possible for you to visit us??? for a week or so. I will insist on sending you train fare if you will come, it would mean so much to both of us.

Well Pops this is all for now, and I hope you will take me up on my offer.
Much love
Cole

February 20, 1944
Cole Boy -

I don't know who this letter is for; it is sent to you because I "owe" you a letter, but it is also very much in answer to Neil's last. So let's consider, as usual, that I am writing to all of you N [Neil], C [Chan], D [Dorothy], even to B [Brett] and C [Cicely] in spirit. Neil asked me: "What do you think about the Russians?" - or correction, "How do you feel?" You really answered your own question Neil, and for me too, by "Judging from their straight forward adions of past and present, I feel like trusting them a lot more than some of our own politicians." I quote you at length because I think you said it all. Behind some of our representatives are such dastards as Hearst, Chandler, and McCormick, men (if you can so honor them) who would rather see Hitler win than Roosevelt. They would split this nation wide open on the subject of our allies, if they could, are doing their best to create suspicion of Russia. Some of the petty business men, the petty bourgeoisie are saying - "We'll have to fight Russia next." Unadulterated BS! How could we in the first place? Transport an invading army to conquer Russia on her own soil? Too funny! And then you hear, "Russia is oriental, she will join Japan." (Hearst should be tried for treason). Russia and Japan are "natural as enemies". One thing is increasingly clear that Russia will emerge from this war as the great European power. We had better play ball. I want to go on

record again as having stood up for Russia when she signed up with Germany: and I stood against a lot of white-livered Communists who were jumping off the band wagon.

I said, and say now, What could she have done, with all the great powers against her, or at least negatively inactive. Russia has known since before World War - 1914 that she would eventually fight Germany (note her clever use of very broad gauge RR tracks) and has consistently prepared for the day. If Russia should make a separate peace with Germany, it would only be because we forced her into it.

Of course, this is far too big a subject for a letter. I started a series of letters on current themes - or age old themes - some time ago, and got side tracked because I could see that I was preparing to spend the rest of my life writing, and I couldn't.
In case you still want B's address"

Prt. B. Weston, 39718487

Co. C.  29th B

Camp Crowder, MO

I wonder which of my boys will be in the army, or whatever, next. I am sure that each of you is going through his own particular Hell at present, so perhaps the armed forces would be no worse. With Civilian death rate, traffic, home and industrial, higher than that of the armed forces, I can't get overly concerned about that angle if you are drafted. What I do wish for you, is creative experience in the art of living, and this experience is largely, perhaps wholly up to each one of us.

I sure would like a picture of Cole in his Coast Guard uni. And sub-machine gun. And one of D - as the "picture of motherhood!" Thanks for the train fare offer. I still have plenty for food and fare (now Charis is supporting me). But I am house and garden - keeper and lots of other odd-jobs to fulfill. So forget visiting until summer. We just put out artichokes, strawberries, asparagus, and rhubarb - and you?

P.S. Reading behind my lines you will find my oft sung theme: I fear the fascists at home much more than those abroad. We can lick Germany and Japan eventually, but not unless we clean our own house of all the vermin that hides behind closed doors, or even sits beside you at the opera. If we don't clean house, I fear great disturbance here at home after the war. We could have a civil war, the fascists would love it, are praying for one.

P.S.  Did you see this in Time?

Gypsy Rose Lee wrote to W. [Walter] Winchell from her sickbed.  "Everyone had flu but me. I gotta get lobar pneumonia, and me with no lobars. At least not big lobars like other girls."

April 16, 1944

Dear Pops,

I received your last letter so will attempt to answer some of your questions. The trip was rather painful on my ankle but otherwise uneventful except for the fact that we ran out of gas at the entrance to the canyon. I hobbled the rest of the way home on the crutches. By the way, did they arrive in Carmel O.K.? I found my notice to report for a physical on Saturday 15th, waiting for me. I went to the draft board and showed them my foot in a cast, so they postponed it until my foot is better. I went to a doctor in Santa Monica, he removed the cast, said it was just a bad sprain, so at present I have it bound in an ace bandage and I can almost walk on it now, though I don't believe I could march on it. Speaking of marching, I just phoned Mom, she had received a letter from Brett in which he said he was to be a truck driver, not a photographer.

*Chandler and Cole Weston    Peter Stackpole*

Have you any news to substantiate this. Chan goes into the Navy on the 29th of this month. I thought I might as well tell you as I am sure he won't think to write. I will let you know as my relationship with the armed forces develops.

You can keep the blanket and cushion if you like and on our next trip we will pick them up. As soon as I finish this letter, it being Sunday afternoon, I am going up to the darkroom and print. I wish I could take you up on your offer on the Art and Business of Photography. Maybe we could figure out some sort of correspondence course, as we live so far apart. I will do my best and send you some for criticism.

Well Pops, I want to get a bite to eat and then GO TO work, so I will close, wish me luck in the darkroom.

All my love

Cole

June 6, 1944

Dear Pops,

Well here I am in Great Lakes near Chicago - it took 3 days and 3 nights on the
train. Tomorrow we take another physical. There is a chance that I might be washed out
due to defective color vision. Will let you know.

Love
Cole

June 9, 1944

Dear Dorothy,

Here I lie on my bed of pain and I do mean pain, my right arm is so sore I can hard-
ly move it. One Tetanus, one Typhoid, and a Small Pox, so far no bad effects except the
soreness. About ten or eleven of the boys ran fevers within 1/2 hour and had to sack in.
Today we received our first pay, known as the "Flying Fin", the reason for the name is this;
you had one sailor give you your pay slips, another hands you a five dollar bill, you hand it
to a cashier and another one hands you back $2.25 in change. Another gives you a slip,
you hand the slip to a girl and she hands you a sack, you take it back to the barracks, open
it and inspect contents you bought sight unseen. They include 2 bars of soap, 1 Lifebuoay,
2 toothbrushes, 1 toothpaste, 1 razor, 1 blue jacket Manuel, 2 packages of writing paper, 1
soap dish, 1 pair of shoe laces and some more toilet articles.

I received my first letter today, it was from Mom, I expected one from you first. I
guess it takes longer from San Monica although I sent your Air Mail and Moms was only a
post card. Maybe your is held up at the Post Office. Hope to get one tomorrow. My what
a pretty picture of my lovely wife. Its been raining all day, now it is foggy. Tomorrow
Captains Inspection, I hope it rains. I am getting a nice cold with shots and everything I'm
pretty low tonight.

All my love sweet
Goodnight
Cole

June 11, 1944

Dear Pops,

Well here I am in boot camp with my monkey suit, part of my shots, hair cut and so
forth. I have been here in base camp for five days, a little over four weeks to go. This is

where we learn to be "Navy". Discipline, body hardening, and lots of salt peter I guess because I've lost the urge. We are confined for over entire boot training to this camp. All in all its not bad, the food is damn good and plentiful, plenty of sleep and lots of exercise. The barracks are very clean and neat and boy do we have to keep them that way. I should put on some weight although I am having my first cold in a long time, I guess its the change of climate and the heavy food. Pardon my lousy handwriting not that it was ever any good, but I am lying on by back in my bunk writing on a book.

I will send you a picture of myself in uniform and hair cut. I am a scream. Well Pops, I guess you can hang out a flag with three stars on it now. When you have time will you drop an old service man a line. I would sure appreciate it, letters mean everything while you're away like this. I will try and answer as soon as possible although I don't know how busy I will be. Well Dad, I am going over to the P.X. before it closes at 2000, in 45 minutes so I will close.

My love to Charis

Love

Cole

*This letter included dried flowers wrapped in plain paper.*

*Undated*

Cole Boy -

- a few posies and fewer words - just enough of each to greet you - Chan phoned last night; he was on his return. Your 3 cornered phone conference must have been fun. Leave it to Chan to put over the real McCoy. We tried to phone Brett when he [Chan] was here, but they would not call him, nor would they leave a message.

Tonight Nancy Newhall arrives for a ten day visit, most of which will be concerned with selecting a proposed E.W. one-man show retrospective at the Museum of Modern Art, season '44 - '45. This is to be a secret until announced.

I am praying that your itinerary will include Del Monte; then Dorothy can stay with us, and you can

*Charis and Edward,*      *George Hoxie*
*1945*

visit often.  What say?  Anything definite?

But don't take time to write, unless you scratch me a hurried card.  I can guess you are up to your ears in training, studies, etc.

We are in a mess of kittens with cat arsetrophe trouble.  Have had to include them out of the house - as Sam would say.  Our furniture suffered.

Abrazo and besos y mucho amor

Pops

June 14, 1944

Dear Pops,

Received your letter and flowers today, the smell certainly brought California close again.  Of course you've gathered from my last letter that I passed my physical O.K.  All I have to do now is pass the course.  I understand they are making it very hard, and that a great percentage are failing it.  I don't think its because the caliber of men is low, at least in our group it isn't, you see about 80% have had from 2 to 4 years of college also several of them hold professional licenses, so if I flunk out I won't feel too bad.  [Cole was in radio school] I think I will try the photographic branch if I can get it.  We are in our second week of boot only three to go after this one.  My ankle is beginning to complain about all the marching and running we do.  I don't know how long its going to last, I hope I won't have to drop out.  I don't like to gold brick, as a matter of fact I like the marching.  We are a fairly intelligent bunch so our C.O. is giving us tricky steps, we are getting along very well.

*Edward*                    *Cole Weston*

Well Pops, there isn't much to say except that I miss you and wish we could have had some time together before I came east, maybe I will get a leave.  Best wishes for father's day, I think I have the best one in the world.

Love

Cole

July 8, 1944
2045
Dear Pops,

Received your swell letter with the enclosed flowers, memories of California at the same time a call from Dorothy in the hospital [she had a kidney stone]. I had a feeling something was wrong as I hadn't heard from her for the past three days. She wondered how you knew about it, as she hadn't told anyone. I am very worried, if only I knew just how bad she is. She said she was much better, but she sounded very weak and tired to me. I know that she doesn't want me to worry about her so therefore she probably minimized the seriousness of her condition. Maybe you could phone Hebe [Stackpole] and then write me. I hope as you do that I will get to go to Del Monte. It would be too perfect for Dorothy as well as for me. I will make every effort to get there. As you probably already know my leave has been pushed up to July 22nd. We expect to get 11 days, this will give me 5 days at home. Would it be possible for you to go to Los Angeles around that time?
Well Pops, mail is going out and I have to get ready to sack in "get in bed" beds are "fart sacks" very appropriate.

      Always my love    Cole

*Undated*
Cole Dearest -

      Hebe phoned me - I wired the doctor - I phoned Hebe - I wrote Dorothy - then -
Dr. Van Fleet [said] " Dorothy better"
And "letter follows"
And Hebe said "Dorothy better —- "
So you must not be upset. If we can get Dorothy here, we will

      Charis may have to go to Washington D.C. on account of her mother is very sick - so? Comes, would Dorothy function here under existing conditions, no car, no conveniences, etc. Much depends on Doctor's letter and Dorothy's own reaction to invite. Will keep you informed. On account of pupil coming, summer tourists, Charis pending departure, can't see way clear to go south for your leave.

      My hope, of course, to see you here. Miss you!

      Brett here for few days. Sends love. Will write. "Reason for this abbreviated note."

      More soon —-

      Yr. Aff. And love    Dad

      and Pops

*Undated*

Cole Boy -

Have not heard from you in ages - guess I'm at fault for not writing. We have written Dorothy twice, - and I just wrote again. Wonder how she is, what are her plans? We still hope for a family gathering up here. Charis has not yet gone east.

No sooner had you boys said your preinduction and leave farewells than visitors and friends started to pour in; among them Sidney Rogers (short wave and domestic radio) for 3 days, and our Congressman George Outland and wife and Zelda are here now. I have a pupil today, another Monday and two sittings (Hill!) tomorrow. I am rather worn and weary what with a string of the armed forces (and some sittings of them, at cost). Helping to get Brett settled in New York was time consuming (writing, developing his 8 X 10 films, shipping, etc.) - but it was a heart warming experience following his devastating days of heavy weapons and truck driving. My pupil is due. This is not much of a letter, but it carries all my love - and from Charis too —-

Your

Dad and Pops

July 17, 1944

Dorothy darling -

Your plan sounds exciting and full of promise. Come on! Way behind in necessary work so just - Hurry up, get well and strong, drive up with your S 1/c.

By this time you will have seen Brett.

Yrs with love from me and all

Edward

August 17, 1944

Dorothy

Sweet ones —

Cole

Where are you? How are your?

How, what and where am I?

First of all your Bro. Brett has taken much of my time because of demands caused by his various and sudden moves.

*Pfc. Brett Weston*

I've had to ship things to him, develop film (he's getting even with me for "Leaves of Grass"), and of course write him how his exposures were etc. No favoritism indicated.

But we have not heard from Dorothy about her plans. Hope this does not mean she (you) are poorly. Do write a line, post card, anything. And Cole? New address? New work?

I have had a terrific summer what with one long line of guests (not all house);many were of great interest, even importance, but the cumulative effect was devastating. A few: Sidney Roger (Radio commentator for O.W.I. Short wave), George Outland, our Congressman, and old friends. Now I have a pupil from Hollywood next week - and so it goes.

I am praying that Cole will be stationed here and that Dorothy will come up soon. Love to Neil, Flora - Write Neil soon -

Must ready for my pupil

Love to my children from Pops

August 28, 1944

Dear Pops,

Just a card to let you know that I am still alive and that I think of you every day and wish I had the time to write. School is tough, tougher than I ever expected. I am giving it all I have. I don't know whether that is enough. Several of the fellows have already been dropped - here's hoping. My hours are up at 5:30 and start school 7:30 a.m. work and study until 9:30 p.m. some days

Much love to you Dad and Charis

Cole

September 11, 1944

Cole Boy -

Just sent Erica back to S.F. after a two week visit. Charis is a whizz with children. I tell her she should have 10, more or less. We enjoyed having Erica, but it was a bit of a turmoil what with summer callers and sittings. She left with a bellyache and poison oak! - but she got a psychic boost. I feel very sorry for the child.

Your hours and studies sound strenuous - I hope you make the grade: you deserve to. Along this line, a comment on Dorothy's smoking, in re her recent sickness: a doctor from San Francisco, of considerable importance in his line, said that smoking had a very bad

effect on diabetics. This doctor is a regular M.D. [Edward and Flora both believed in homeopathic practioners and cures] I don't want to moralize just because I re quit, but I thought Dorothy might be interested. Shall I tell her or will you - or maybe she knows and has quit! Besides my leg, which in now good enough to dance on all evening, I no longer have dizzy spells, heart flutters, lightning flashes in eyes - in fact thanks to quitting cigs I think I will live an extra ten years!

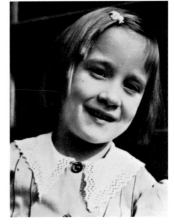

*Brett's daughter, Erica*

We had a party Saturday night. A good time was had by all but I sure miss you boys and girls, especially when well remembered records are played. You, and your brothers were always the life of the party.

These are stirring times: despite the great victories in Europe, I can't shake off the fear that China might collapse. What a mess that would be. John Short is off Pacific Bound, apparently China. I dropped him a note. Marie [John Short's mother] said he was very lonely, unhappy. I hope you are registered Cole and will influence all your friends and relatives to prepare to vote. "That meager little man" must be defeated, all the reaction, the status quo (of the 20's) must be crushed. If we have another weak peace it will very likely mean civil war in this country.

This the next day, another cold, gray, drizzle: this year has out fogged all others that I can remember. I have not kept track but I venture to say that the sun has not shone more than 10 times in the last 3 months and then only for a few hours - I don't know how anything has ripened. We eat regularly, and give to our friends, from Victory garden; zucchini, other squash, 3 kinds of lettuce, peas, beans, onions, carrots, beets, chard - and you can guess the rest.

Don't write, not until you are safely through your studies.

Great love to you

Dad

Pops

September 18, 1944

Cole Boy

Just a word between writing Steichen [photographer and in 1937 became the Director of Photography at the Museum of Modern Art] and getting Neil's sweater done

before he leaves. [Neil had joined the Merchant Marines] My part has been to read to Charis while she knits. Of course I'm terrible sorry - for you - that you "flunked" [radio school]; but I'm sure you will take it in your stride.

I wrote Steichen at once; but don't hold too many hopes. First of all I'm not a close friend of Steichen's - have only met him once; second, he may be in the Pacific Area quite out of immediate reach; third he may think that I have put him on the spot, since he only has my word about you to go on. I wrote a carefully considered letter from all these angles. Another possibility: Steichen may be a bit peeved at Westons because Brett turned him down. [Brett did not join Steichen's photographic staff.]

Chan, Ted, Neil, Dorothy phoned last evening. I was developing 8 X 10's in dark-room but got out in time for a word. Dorothy sounded very chipper, almost fat.

We are on our way to town —

Much love dear boy -

Yr   Dad

September 18, 1944

Dear Pops,

Now that it's all over I have time to breathe and write, I suppose Dorothy has told you all about it, but I will give you an idea of what it was like and why I am glad I'm out. For one thing I couldn't see driving myself into a nervous wreck for something that is not allied with what I want to do after the war. It was without a doubt the toughest most nerve wracking three weeks I've ever spent or hope to spend. From the 1st week on fellows began dropping out until by the third week along with the 150 fellows who dropped out after comps, almost 50% of the 500 men had washed out, so I didn't feel too bad about it as I stuck it out to the end. The Navy does the damnest things. They wash out fellows who have had years of radio, hold commercial licenses etc. just because they are a little rusty on math. I was O.K. on my math but the electricity got me. I flunked the last two tests so out I went. I could have repeated but I didn't want it, as the following ten months of school was to be twice as hard. Most of the fellows who got through had college training or were just out of high school, which is a lot different than my case. I stayed in every Sunday and Wednesday liberty and studied until I became crazy and my eyes would blur, so I couldn't make out the problems, then and there I decided to hell with it, my health and nervous system were more important to me that to learn another trade, so tomorrow I go back to O.G.U. and hope to get into photography. If Steichen could do something for me it would be swell, otherwise I don't stand a chance.

What I wanted was just something to let them know that I might be material for a photographer due to the fact that I've been around it all my life, not that I'm any good or claim to be one. If I don't make that I will try for aviation metalsmith. I should get this if the school is open. If you do get something from Steichen send it to O.C.U., Post Office, Great Lakes, M.T.S. ILL. What do you think about your last son getting into this mess. It was a shock to me as I expected Neil's headaches would keep him out. Now you can hang a flag in your window with 4 stars on it, oh joy, what a life. Yes, I have registered and plan to help defeat that "meager little man" as you so appropriately name him.

Would you send me John Short's address. I would like to write to him, also David's [Hagemeyer], as I have lost it. By the way one of the fellows that I went around with is now at Del Monte, he will probably phone you up or perhaps he has done so by now. A nice fellow, John Richardson is his name.

Do you remember Chuck Scott, the boy I went to kindergarten with, he was killed in Guam. He had been through every battle from Guadalcanal "sp" "Twrawa" Saipan etc. Poor kid, he had more than his share, five years in the Marines.

Well Pops, I have to get my gear squared away for tomorrow so I will have to stop now. Give my love to Charis. I told Dorothy about the smoking.

Much love

Cole

September 24, 1944

Dear Pops,

Received your letter today, also had my interview. It went like this, "well what do you want?" Photography, "no photography!" but you see I have been - "no photography!!" I only want to tell - "no photography !!!" but - "no photography!!!!" etc. until I got so damned mad I could hardly talk, he wouldn't let me get a word out, so he put down 1st choice aviation metalsmith, no 2nd. Well I decided I had a raw deal so I went to the head lieutenant in charge, the interviewer was just a stinker 2nd class P.O. All I did was mention the name Steichen and his face lit up then my association with photography and how all I wanted was a chance to show what I could do. He phoned a higher up and said he had an XRT here with exceptional photography abilities etc. etc. I practically blushed. I didn't know I was such a convincing talker. Well there still wasn't anything they could do. I just hit it at the wrong time. Photography was shut tight as a clam. My only hope would be to go to a service school then get a letter from Steichen, present it to my C.O. and that would do the trick. But there still remains one little hitch and that is my color vision. When the

lieutenant learned about this he just about gave up hope. You see all photographers in the Navy have to qualify for air combat crews which means its almost all aerial reconnaissance work, at least the school is. He said though that a letter might get me in anyway and wished me the best of luck. Color vision is the most important single disqualifying element in the Navy. You may as well be crippled, blind, deaf, etc. for all the jobs they have for a color blind man. Its very discouraging; cooks, bakers, grease monkeys etc. Well I will know my fate in a day or so. I still haven't given up on photo.

All my love
Cole

September 26, 1944
Cole Boy -

Your good newsy letters here. It is warming to know that your spirit is high - or at least not too low. As I hinted before, don't put much hope on Steichen, he may not get the letter for months! I also wrote (hinting) to Dave McAlpin who is Lt. Cdr., but feel sure he will not be in position to do much. Maybe I am pessimistic because of the failure of all my efforts in re Brett. I kept the Army busy via Brig. Gen. Peabody to no avail. One thing I told Steichen was that you had been around or in photography all your life - practically your letter word for word.

I hope you have access to a radio, and heard FDR's speech to "teamster's union" - it was one of his great political speeches. And I hope you heard Dewy's answer: he was mad as hell, and left himself wide open - a small town D.A. in action. Listen in if you can because this is history in the making.

We got Neil's sweater off just before he left. I can hardly grasp the fact that he has sailed. I hope for him a great adventure.

Yes, I recall Chuck from a little boy on up. I was very sad to hear the news. In fact, can't get him out of my mind.

Dark room today. Cats! My new direction -

Great abrazos
And love
Dad    Pops

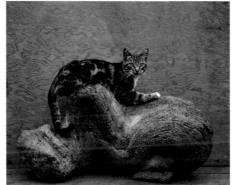

*Johnny, 1944*                    *Edward Weston*

October 9, 1944

Cole Boy —

Just to say that I rec. yr new address. Will write soon. Have a few orders to get off this week, of birthdays, holidays, etc. Sure miss my scattered family.

Much, Much love

Dad

October 10, 1944

Dear Pops,

Received your last while at O.G.U. but as I was about to move I didn't have time to answer. I have just finished my 2nd day of a 21 week course in aircraft sheet metal. I must say that there is nothing to it after R.T. [radio training], only 6 hours a day instead of 12 to 14. They are very strict on this base almost as bad as boot camp, we march to and from class and chow, clothes have to be just so, its very tiresome.

Dorothy will be coming out around the first of November, its

*Navy photographer, Cole Weston*

been a long time since we've been together. I hope I can find a place around here for her to live in. I am going to try for an instructor's job which I understand I have a good chance for due to my teaching experience. If I could get this I could live off the base, buy food at the commissary on base and live almost a normal life.

I haven't written Neil yet, as I don't now where he is, have you heard from him.

How is everything down your way. Charis, the garden, cats, etc. how I long for those days of sitting around the fire with a mug of coffee in front of me, maybe now again we will all be together. At times everything seems to be in such a turmoil that the chance for a normal life seems to be just a dream. History might be in the making, but I wish it had not chosen my lifetime to do it in, at least not until I had my feet firmly grounded in my chosen profession. I guess this is selfish of me.

Well Dad, lights are about to go out.
All my love - your son in turmoil
Cole

*The following letter is included because Cole remembers getting a similar letter.*

November 7, 1944
Neil Boy —
This is one of the most fateful days in American history.  I am just about to go to the polls to vote for F.D.R., one of the greatest presidents we have had - perhaps the greatest considering the crises of the last decade which he so magnificently met.  As for Dewey, it would be a national, - more, an international calamity if he were elected; his campaign has been one raucous round of lies and vilification; a nasty little man who has the nerve to speak of "my opponent".  Enough!

November 8 - and "we" have won!  Won a great victory.  I hope the Republican Party will know enough to nominate a man of dignity next time instead of a small town D.A. like Dirty Dewey.  I will never forgive nor forget that man for his campaign of lies.

Love    Pops

*Victorine Ranch, 1943*                                    *Cole Weston*

# 1944 - 1946

By now Cole is actively taking photographs and sending samples to his father to critique. He has made contact with photographers at the University of Oklahoma and is doing some work for the Navy as well as taking portraits of sailors to send back home to their families. Discharge papers come in April, 1946 and Cole and Dorothy travel to New York to attend Edward's opening at the Museum of Modern Art. While in New York, Weston family friend Peter Stackpole convinces Cole to become a stringer for Life magazine. Stackpole, one of the four original Life photographers and his wife Hebe are close friends of Cole and Dorothy. The job is short lived. Cole is scornful of the magazine's practice of shooting hundreds of frames to get one shot. He is realizing that his father's passion for "straight" perfectionism in photography has made an indelible mark on his creative consciousness.

Edward and Charis divorce in 1946, leaving Edward in a state of flux. He isn't sure he will be able to stay at Wildcat Hill or even in Carmel. The land had been owned by Charis' father and Edward is certain he will have to move; but Charis changes her mind and sells the property to Edward. After lengthy correspondence with Edward about their collective futures, Cole and Dorothy move to Carmel. Cole becomes Edward's assistant, starts his own portrait business and becomes involved in the theater again.

In August 1946, Eastman Kodak asks Edward, now suffering from Parkinson's Disease, to photograph Point Lobos using the new Kodachrome color film. Edward's reply: "I don't know anything about color, but I do know Point Lobos better than any one alive." Cole goes along to assist his father. He starts by carrying the equipment but as time goes on, he is placing his father's increasingly unsteady hands on the focusing knobs and helping him walk. Because of Edward's frailty, the color film, which has already been loaded, is not being used. Cole begins experimenting and finds he likes this new medium. He shows his

father the work and Edward approves and encourages him. From this ironic start, Cole becomes a Master Color Photographer.

Edward dies in 1958. In his will he states that Cole can print from his negatives with the stipulation: All prints must have on the back of the mat -

Negative by Edward Weston

Print by Cole Weston

And no prints can be sold for less than $30.00. Cole prints from his father's negatives until 1988 when he decides to print only his own work. But Cole's life in Carmel, his wives, children, and photographic work is another story.

*Nude, 1934*                                                                 *Edward Weston*

November 18, 1944

Dear Pops,

I'm sorry for not writing sooner but what with Dorothy arriving and school I have been very busy. The school isn't tough but it takes a lot of time.

It certainly makes Navy life and school much more bearable with Dorothy here. I have the weekend off and also one night a week for being squad leader and besides this we sometimes get an extra one for marching etc. so you can see that we have lots of times together. On nights that I can't get off Dorothy can come on the base, we go to a show or just walk around. Its swell having the car here, makes life almost normal, and to add to all of this I have just had a terrific break. Dorothy was over at the University of Oklahoma to see about dance classes etc. The dance teacher knew many people that Dorothy did and also gave us the names of several people to call, you see I have been trying to get a dark-room so I can do some work. Well one of the persons we were to call was a fellow by the name of Leonard Good, the photographic teacher at the University. Dorothy phoned him and said that her husband was trying to find a darkroom, he replied that he had about 25 students so the darkroom was very busy. Then Dorothy said something about my husband's father Edward Weston, well, I now have the use of the complete lab. Including chemicals, film, paper, etc. anytime I want it. It turned out that Leonard was not really the photo instructor but the professor of art and was just teaching a small class. He studied with Charlot in Iowa and has many mutual friends of ours. He invited us over that night, it was wonderful to talk to "people" civilians again and discuss something else besides Navy. From there we went to one Charles Fant who is a great admirer of your work and has a very old adobe home in Taos, New Mexico, old friends of Mabel Dodge Luhan. Well from this you can see that we have made some swell friends, both Dorothy and I are very excited about it all, as it offers us something besides U.S.O. lounge rooms to go to. They have a tremendous amount of equipment and Leonard has placed it all at my disposal, cameras and all from a new 8 X 10 to Lecias. He is such a swell fellow, young and very interesting to talk to. He studies at "Whites" in New York where, when your name is mentioned he says everyone practically says ALLAH!!! I already have several orders from some of the boys on the base. I'm going tonight and develop. Forgive this disjointed letter but I am trying to write in a hot steaming barracks with 140 other sailors singing and talking, its cold and raining outside.

I can't tell you how excited I am about the chance to do some work. Do you think I'm too old to start photography, no, I know that I'm not but it seems as though so many years have gone by and what have I to show for it. I'm going to get in and dig, maybe I will be able to show you something when I see you next. By the way, do you have a show

that you could send out here, to be shown at the University. There is no rush for it but if you could get one up I know it would be greatly appreciated. Send one of Charlot and Zohmah together. It's already sold.

Well Dad, I want to get this in the mail so I will stop now. How is Charis, the garden and cats, did you say 27 or 37.

Much love

Cole

P.S. Would you send me your formulas, the ones that you gave me before. One thing Dorothy forgot.

*Edward and his cats, 1950*
*Beaumont Newhall*

*Amidol Formula*

For full emulsion speed such as used for cats, when fractions of seconds count, use Agfa 12 (metol). When speed is unimportant, and longest scale is very, my old Pyro formula follows.
When using, double given Weston rating, or even triple. You can examine by green light after 15 min. (I do not need to desensitize)

Stock {

A: Water 32 oz
   Sod. Bisulphite 1/4 oz 35g
   Pyro 2 oz
   Bromide 16 g

B: Water 32 oz
   S. Sulphite 3 1/2 oz

C: Water 32 oz
   S. Carbonate
   mono hydrated 2 1/2 oz

} Data for Sarah

To Develop
   Water 30 oz
   "C" ——— 1 oz
   "B" ——— 1 oz
   "A" ——— 3 oz      70°

*ABC Pyro Formula*

December 4, 1944

Dear Pops,

No answer to my last letter so I guess you have been very busy. I would like to know about the exhibition, if it is at all possible for you to send one. I think Dorothy has written you about my sittings, 4 done so far and several for next weekend. I feel that I have done some fairly good things, at least my clients are pleased, they all said that they are the best things they have ever had done. I don't charge them very much, just enough to cover expenses and a little extra for my time. $5.00 for sitting of 9 to 12 negatives. From these they get a choice of either one of the following    1. Two 4 X 5 mounted. 2. Two 6 1/2 by 8 1/2 enlargements unmounted or   3. Four unmounted 4 X 5. From then on they are $1.50 for 4 X 5 mounted or, unmounted 6 1/2 by 8 1/2 enlargements, and 75 cents for 4 X 5 unmounted. Does this seem fair to you, it's about 1/2 what the studios around here charge for tinted crap.

What I would like to do Pops, if you wouldn't mind is to send you a print and negative with my data on the print. Then if you would criticize the prints and if you happen to be printing, make up a print with your time exposure etc. on the back of it. I will be able to find out what my trouble is. My prints seem to lack brilliance, they are not bad and the fellows like them but I'm not satisfied. I received the tri-pod head, thanks, I still can't figure out how you happened to have it. I thought Brett had it. What printing paper do you use "Haliod" still. I've been trying to locate some proof paper but is non-existent in Oklahoma. Is it available in California, if so I would appreciate if you would send me a box C.O.D. also how much was that phone call I made collect to you from Chicago? I'm so excited about working again. I spend all my time in the darkroom. Dorothy is turning into a good darkroom lackey. She does the mounting and proof making, she is going to try spotting the prints now.

Well Dad, I have to get ready to shove off for school. Have you heard from Neil, where is he, Hawaii, last I heard. Write me soon.

> Love to Charis
> All my love
> Cole

December 12, 1944

Dear Pops,

It was certainly swell to hear your voice again and Brett's and Erica's too. How we longed to be with you on that day especially. The reason for my lack of correspondence is photography, I have had as many as 4 sittings a Sunday, 36 negatives, that's a lot for me. I have done some pretty nice things of neighbor's kids, and have many more waiting their turn. The usual comment on the photographs is "Oh! they are so different from the usual type of picture." It's funny that just good straight natural light photographs are a novelty. So far I have had only one unhappy customer. She didn't like the "cords" in her neck, frankly I thought they were quite stunning. Aside from her, everyone else is very pleased and have done lots of re-ordering. I have more sittings than I can handle. I'm certainly getting some marvelous experience and the extra money does come in handy. My 18 system magazine is not enough, I will have to get another 12 I guess.

School is coming along fine, we are finishing up our 14 weeks. We are in welding 4 weeks of it. They say I am a "natural born welder". I have so far had the best grades, best projects turned in even though there are several welders with as much as 5 years experience behind them. It just seems to come easily to me. It's all rhythm. Well another vocation learned.

I have had my first interview for instructors position, expect another one in a week or so. I guess Dorothy has written you all the news there is. I just wanted to let you know that I am still alive and that I think of my wonderful Pappy often and that I would give anything to be able to spend some time with you in the darkroom. I have to get ready for guard duty at 1800. I am a life guard at one of the pools.

All my love
Cole

December 20, 1944

"Dorothy and Cole Weston" came so natural-like that I did not remember you are no longer civilians. Well don't forget that I was in the Armed forces before any of you boys. Dorothy's letter yesterday. And one from Mr. Good which I answered accepting his invite date April 1.

Brett out of hospital (on account of leg wound and grain), and reclassified "limited service".

Report of Zohmah Charlot, one for Leonard Good is yours for the asking, but you or he will have to get written permission from her. This is a "professional etiquette" rule I

have held to for years. I would send at once because he is public property - and artist!

Your letter sound full of pep and enthusiasm. I'm glad.

This is sort of a Xmas letter - Just to send a posy and love -

I thought your greeting a scream - Who! Did?

Charis in Washington D.C.

xxxxxx Pops

*Dorothy, Battle of Norman and Cole*

Dorothy, I have often wondered how insulin and dancing mixed.

January 20, 1945

Dear Edward,

Just got your card and am quite satisfied with the trade. Will make up the proofs next week and send on to Brett. Cole had a long letter from him in New York where I gather he is living the life of Riley and that Charis is there also. We really feel quite envious. I believe Cole has just written to you and I wondered if he told you yet that it's almost certain he will get that instructors position? He had his final interview with the Lieutenant which was highly successful. Cole felt he talked well and fluently and was completely at ease. The Lieutenant was evidently impressed, also with his grades, for Cole rated 92 in Welding class for the week, the highest mark ever made in that particular work - and he's never welded in his life before!!!!

If Cole doesn't send some of his work to you soon, I will, even if they be only extra prints and un-trimmed. We have made another change in our prices - no 75 cent unmounted pictures. Oh, how it hurts to hand those out! So with a 5 dollar sitting they get 9 proofs and 2 mounted prints or 1 enlargement (horrors), and if any body wants unmounted they can have 2 for the same price as above. If people don't stop asking us to tint I'll start carrying a soap box with me and give little tirades on the evils of tinting portraits.

Last Sunday was one of those darkroom days. Our paper had fogged - in places, how we don't know. So we were there from 10:30 to 3:30 when we beat it home for a sitting,

then back again for another session until 8:30 when we returned home weary but triumphant!

How we wish that we could some how spirit you away from Carmel and into the darkroom for a couple of hours! Of course that's not the only reason we'd like you to be here. We have been trying Amidol developer and it certainly makes an amazing difference. Cole is getting pretty consistent in his work, altho he has a tough time with the women, so help me, they never like their proofs. I guess they can't take it. Usually I am the one delegated to tell them to practically wash their faces first, and then I sit on the edge of the bed and talk my fool head off so that by the 7th negative they are a little relaxed. Give me children any day, or even the sailor boys. Why do most women photograph like the little bitches they usually are?

I had a grand letter from Marie Grocup, full of you, to quote - "And Edward looked like the rock of Gibraltar and beside him I felt like an insecure piece of driftwood being tossed about in the bay. His very simplicity over whelms and I become tongue-tied and all the foolishness I have in my mind about problems become so high-lighted to me that I feel like an adolescent child that should have it's bottom spanked and it's nose wiped clean. If ever I can attain the security of mind and directness of purpose and remain as generous and as good as he is, then I will feel I have become a truly 'real person' - unknowingly he may become that piece of supreme normalcy that one can lose touch with so quickly." So there you are Edward, and I guess we all feel that way in a certain degree.

We are toying with the idea of asking for Erica - as we will be here 2 years and as Cicely's and her mother's letters make us feel a little sick at heart. Cole is going to write to Brett about it. What do you think? We want to do the right thing by Erica and would love to have her with us again.

Heaven knows when I can have any more children. I still haven't been able to have much of a discussion of the subject with any of the doctors, besides they are most evasive, saying, "Oh, we could probably pull you through.", which thought at the moment rather terrifies me. Also I would hate to pass on diabetes to any child, of which there would be a possibility. Cole and I have discussed the matter and feel that if this were the case, we might adopt a child and Cole says - no one else but Erica. However, time will tell, and right now we are pretty happy just to be together and work together. I am often amazed at how happy I feel, just perhaps walking to the base to meet Cole, or working with him in the darkroom on a Sunday morning. Our only times of depression are when we think of you all so far away and how there is really no-one to talk with. The University people are pretty busy and we rather feel they think of us as pretty much like kids. If they only knew what the few evenings we've spent with them really meant to us. Maybe we're inclined to be

snobs, or I am, for I think if I listen to any more mangled grammar and conversations about nothing at all, I shall start correcting their grammatical errors to their faces and then become a recluse. How we long for some good music, good company. This is all probably brought about by Brett's letter and his description of his activities. "Say, listen kid" is beginning to grate. Oh where is someone who's read other than detectives stores and the Red Book? Perhaps we could do with some of that soul searching you mentioned.

We have had some grand letters from Neil. I think Cole misses him very much, and always at the back of mind is worried about him. We almost wept over his last letter, I guess he's told you of his post-war dreams - of living somewhere on the coast of British Columbia, getting married and raising a family. Cole has been talking more and more of really keeping on with photography after the war. I think his understanding and appreciation of people, plus his enthusiasm and sensitiveness would make him particularly adept at portraiture (discounting the technical end of it). He is very happy doing the work.

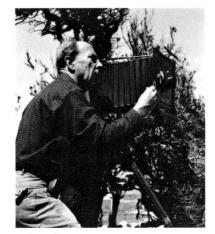

Well Edward, this had been a long letter, longer than I originally intended, and I must now go to the post office and also shop for Cole's dinner. Do write again soon. We look forward so to your letters.

All my love
Your "Datter" Dorothy

*Edward Weston*

January 29, 1945
Happy Birthday
Dear Cole -
and good photographs to you -
I can't possibly answer your good long letter - yours, and especially Dorothy's - because my mind is teeming with all the things I would say in re your new adventure - photography. Naturally it is a tremendous subject to me, has been for 43 years. So I am stymied when I try to say anything, give you advice in a mere letter. So for heaven's sake get a leave and we will sit, or lie, up on the flat and talk it out.

There are two approaches, maybe three, to any art: you can make it a real business first of all, in which case "Art" could, probably would, be killed; or you can live for your art, and maybe grow lean in the living, or try to combine the two approaches. In trying to

achieve the latter, I have learned that you can't make a lot of money, get rich, out of your own hide, no less than the corner grocer; that if you wish to go alone and live an unharried life, eat well enough, and support wife, mistress or children (or all six at same time) then you must give the public something they can't get elsewhere, and you must cut down, keep down overhead.

Obviously if you give your public something all retouched and glamorized, you are at once competing with the "BeSaw Gallery" on Main St. and you will fail because he (Mr. BeSaw) is hiring cheap labor to work long hours and you can't compete.

Moral! Try to get a select, though maybe small audiences, and raise your prices as fast as you can. (I always did when more work came in than I could handle).

I am writing about your future. Now you are learning, profits are secondary. Cover your expenses, and acquire experience.

You will get disappointed sitters, of course, who expect the usual, but you will get more who will say "Oh! they are so different" (to quote you).

From this incoherent letter you can see that I am bursting with so much to say that most of it will not get said until we meet.

Now I must end this -

Write Neil -

"   Charis

"   Chan

"   Brett

yr ever love  Pops

March 6, 1945

C and D

darlings

Yr (D's) long letter crossed with my express package to you. Your temporary home brings to mind ours in N.Y. with maid, valet, and doorman, 1941.

All news is good, but especially that furlough. I claim you this time. Do you realize that I only heard your (Cole's and D's) voice on last leave? Didn't lay eyes nor hands on you? Besides, we must have some photo-sessions, real jam ones -

It's 56 at noon in this room and sun is out too. A real Calif. winter day. My hands are too cramped to write and must now turn to spotting. Enclosed is self explanatory. I was shocked to find how poor Azo quality is. But Haliod is none too good. No decent paper made I guess.

Exhibit for Okla. U. all tied up to ship next time we go to town (this week). I am sending early to avoid my other obligations due this month end. This is the way I size up shows: mounts (all inexpensive mounts I used for traveling shows) are in pretty bad shape - prints not much better - selections are all from work prints to 1937 (Guggenheim) - but this includes some very important and historical photographs. I am not apologizing, rather explaining. You caught me with my pants down. I just can't spare recent work from my selection for M.M.A.(Museum of Modern Art, New York)

I will explain all this to Mr. Good. His print of Charlots is on Shathmore [a mounting stock]

Love    Dad

*Letter continued*

I made print on No. 2 Haliod (exposure 5 sec.) Print down dress 3 sec - which was a little too much. The two prints illustrate the difference between contrast and brilliance: the Azo has as much contrast between black and white but no gradation in middle values - it's flat (the paper) does not record the hill scale of your negative. The Haliod print gives roundness to bead (I mean modeling) sparkle to hair, etc. Don't think this is the best print that could be made, not Haliod the last word in paper. I have great difficulties in getting grades of Haliod to run even - some are too contrasty, some too flat.

By the way 5 sec is too fast an exposure, no latitude. I was too lazy to change 200 w bulb, which I use about 1 yd away.

1. Your background too close to subjects. Can't you put it further away? And get yourself a dark ground too. Your retouching a bit overdone. Grain may be Newton things - get yourself a sponge rubber pad or thick feet for a better contact and use same. Man looking up is of course bad - happens when using Graflex for obvious reasons. 2. It is easy to get careless with out focus distance. But you do well with children. 3. Not undertime. Look at detail in shadows - close values between face, dress, ground, but not so bad as you made out. "She likes indoor ones" because she thinks they flatter her more. Neg. could be considered under developed but not for Azo 2. I like 4 & 5

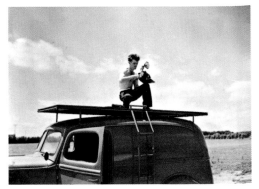

*Cole*

best or better. "4" is beautifully timed and developed - "5" could have had more exposure for hair. 6. Yes, a little "out". But a little under ex. too. 7. Your pin up a good negative. No#1 better. 8. "Grain" does not look like Newton Rings - maybe defective paper; frankly not sure - for fog-test, develop 1/2 of an unexposed test of your paper in question, for full time (3 min) then fix. If you can see any difference between two halves, it means you have fog or stain, increase bromide, I use "B.B." compound (defender) to replace some bromide, gives colder color. Never weigh grains on cheap scales; not true - make up your 1% solution on less that 50 grams - measurement. I use 2 oz. "B.B." compound to 2 oz. Bromide 10% in my 40 oz. developer.

9. Top negative in every way. #1 better I think but I don't care for green black. Worse is a real blue black. I try for a real neutral black. 10. Not undertime (see plenty detail in shadows). Not under developed. What you don't like is a result of too close values, no separation between face, clothing, ground. Maybe fog caused by leaking light trap. Careful to keep covered, especially when putting in slide (always square). 11. Negative defect (I'm sure) too bad! "Framing" good. I would return film to factory. 12. Excellent child print. 13. Negative well exposed and well developed. I would not hold back shadow. Always dangerous to upset balance already set by nature. Of course, I do on occasion.

14. Excellent negative. When you use retouch dope cover entire negative quickly with a drop or two on cotton. Covering just part is likely to show. I am keeping this one to print for you. Doubt if I can improve. You have done well by your "poor" ones. Just remember that you can't get perfect prints from a bad beginning. 15. Expression, eyes, better in this one. But did you recognize bad fog on negative? It seems to be all over. Dark room light? Is your lens well shaded? and clean?

All in all, keep up the good work. I am pleased with your direction.

May 5, 1945

Until I have a moment (or an hour) to answer your long one (they say Spanish "gracias para la flor" but I don't deserve quite all the flowers), until a letter then, use Haliod Industro.

Your Papa

June 11. 1945

Dear Pops,

With a terrific storm raging outside, pipe in my mouth, full stomach after a hearty breakfast with Dorothy, who has gone to work, I decided it was about time I answered your letter. I know now why all the Okies go to California, for the past two weeks we have had the most terrific lighting, thunder and rain storms you have ever seen. The lighting is so bright and thunder so loud you can't sleep. A bolt of lighting 3 feet wide struck just outside of our window the other night, it damn near knocked our new home down, I say new home because we have moved to 1726 E. McKinley. I don't know whether Dorothy wrote to you about it or not. It is in one of those housing projects built like barracks with only a paper mache wall separating you from your neighbor on both sides. Even with this disadvantage it is heaven to be able to leave the dishes, eat when you want, go around half naked, play the radio and do all the other things that you can't do when you just rent a room. Its comes to the same price. We have a two bedroom deal, one of which I am going to make into a makeshift darkroom which I need desperately. I have been doing a great deal of work for the photo lab. Mostly speed graphic work with flash and some 8 X 10. The fellows in the lab can't get over the amazing luck I have, always good sharp negatives when they turn out "fuzzy-graphs" or blanks half of the time. I covered the "Charlie McCarthy" show with Don Ameche, Ray Noble and his orchestra etc. It was the biggest show ever to come to this base, and therefore it was very important that photographically it must have a thorough coverage. I went along with the head of the photo lab, to make a long story short, they used all of my shots as they were the better of the two. That show was the turning of the tide, they now decided that they must get my rate changed to "photo mate" and get me permanently into the lab. Well the A.M. (Aviation metalsmith) school has other ideas about this, they don't want to release me, so little Cole has the bright idea, why not ask the heads of the school if I can be the official photographer for the school, they've never had one before, in fact there has never been such a position, until I thought it up, well they seemed to like the idea very much so I will know sometime this week if it is approved. If I get it, it will mean I will stop teaching and just do all the photography for the school which will be very interesting. I will let you know the results. Now, even a bigger photographic venture has been given to me. The "Architectural Forum" the biggest magazine of its kind in the country is running a big story on the new proposed "University of Oklahoma", which Henry Kamphefner has designed and submitted to the board of directors. Well a representative of the Forum flew out from New York to get the layout and background for the article. As they will need photographs of the present University showing the decadence of the present architecture, Henry called me in on it, of course I was

delighted and was willing to do it just for the prestige of having my name in such a good magazine. We had a conference with the "Forum" representative last week to talk over the number of photos needed etc. Well she being a New York gal knew of your work etc., so when they had decided on 9 or 10 different pictures she said, "Now about the cost, of course we couldn't possible pay the same price your father would get for such a job like this" she seemed very embarrassed, "we don't pay much" it went on for a couple of minutes like this, then she said we pay $10.00 per print, well I can tell you $90.00 or $100.00 seemed like a lot of money to a guy who was proposed to do it for nothing. Well after further discussion she gave me a deposit and left. So you can see from this that I am very happy. I have until July 1st to deliver the prints, nine 4 X 5 contact prints unmounted, fairly contrasty for publication purposes. I understand they will be very small in the book, but who am I to kick with 90 bucks in my pocket toward a camera or something.

I spoke to Leonard about the money for your prints, he said he would check on it immediately. Will try to get into Okie Photo supply and get some proof paper if available. I had two sittings yesterday, Mr. and Mrs. Kamphfner with 3 more for next week, so you can see I have been very busy.

Well Pops, I hope my letter doesn't sound as though I think I am a success because I don't mean it that way, but I am very happy with the turn of events. Enclosed are a couple of snaps that Peter [Stackpole] did of us in Los Angeles, couldn't remember if I sent you any or not.

All love
Cole

P.S. When you go to New York, come through Oklahoma if possible, either on your way there or back. With new house we can put you up and I will take you out to the base and have a swell time. Please.

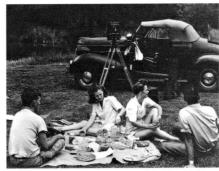

*Cole, Dorothy and the Stanchfields, 1945*

Dear Edward.

Just a note to add to Cole's letter. Very exciting things seem to be happening to this couple of Westons and maybe being in the Navy will turn out to be one of the biggest breaks in Cole's life. Seems that the New York representative for Forum magazine was very impressed with Cole, his charm, etc! and our friends really

went to the bat telling her what good pictures Cole takes.

What weather! Cole's description is really an understatement. The thunder never stops growling and the lightening flashes continually until your nerves seem all ragged edges. Also it is very humid, the least exertion and you start to sweat. The lab here is terribly hot, there being no ventilation to speak of and we can't open the windows on account of the dust blowing in and filtering into all the equipment, even the magazine. So we sit here and sweat it out every day.

Well, Cole seems to have covered all the news. Oh yes, our new address is "Hillcrest Courts", the new number is 1726 etc. Hillcrest is really funny, as it is the flattest piece of land in all Oklahoma. We are having fun fixing it all up as it was unfurnished and Cole is making furniture out of packing cases and I am making curtains out of cheese cloth. It is good to have a little house again.

Love to Charis and all love to yourself
Dorothy

April 30, 1945
Dear Pops,

I hope you will forgive me for not writing sooner, but I have been very busy trying to get back into the swing of things, after such a wonderful leave. You will never know what those six days with you meant to me, photographically and otherwise. Your calm, collected and simple approach to the complexities of life will always be something for me to remember and think about I've always felt that if in my life time I can become half the person, make half as much out of it as you have, I

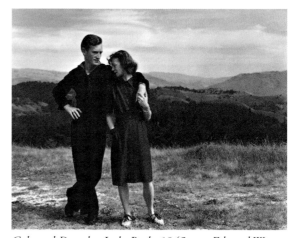

*Cole and Dorothy, Jacks Peak, 1945*    *Edward Weston*

will be satisfied, after our wonderful visit I feel this even more strongly. As far as helping me photographically, don't for a minute think that you failed, after all in 6 small days how could you expect to give me more than you did. Soon we will have more days in the darkroom without the feeling of time pressing upon us. I only hope I can remember and use

half of what you tried to pound into my cold glazed brain. What is the type of "Haliod" you use, is it Industro? Would you send me the complete name. My graphflex lens is 10 so I shouldn't get distortion working close to my subjects. We received your "Jacks Peak" photo of us. I think its terrific Dad, its so alive, everyone who has seen it is amazed at how real we seem. I will make up proofs of the one you did around the house and send them to you.

There is an opening here for a photographers mate 3/c but the A.M. [aviation metal-smith] school wouldn't let me go I'm sure. I don't want to press the matter as they are cutting the school compliment 20% and they might decide that if I want to get out of the school so badly they will just send me to sea. So I think I better let well enough alone. My cold is just about gone, its one of those hangers on, but much, much better. You said that you got a touch of it, I hope not Pops, at least I hope it wasn't as bad as mine. I have given up coffee and cigarettes again this time for good, my nerves won't stand that much stimulus. I haven't smoked since getting back and don't care for cigs nor do I crave them, it's just something to do and I've decided it's not worth it. I have Charis's carton of "Pell Mell" ready to mail, so tell her I haven't forgotten our little bet.

I do think it will all be over in Germany before you get this letter though. If Russia helps us with Japan, I don't think that will take many more months either, here's hoping anyway.

I have been talking to some native Okies and have learned of something supposedly terrific photographic material near by. Weekend after next we go to Turner Falls about 75 miles from here. I hope there is something there and the weather is good.

From all reports your show [at the University of Oklahoma] was very well received. They had a tremendous turn out and by people who didn't come just for the social part of it, in fact as Leonard put it, they looked at every one of them, instead of the usual glance here and glance there, and then have a gab fest. Leonard was very sorry he didn't sell any more than he did.

Well Dad, it's about time for me to pick up Dorothy at the lab so I had better get dressed.

Much love

Your "hope to be a good photographer son"

Cole

August 5, 1945

Dear Pops,

Sunday morning and a few minutes to rest and relax in, after two weeks of hard work in which I made over 150 4 X 5 exposures, that's a record for me. I am illustrating a book for the Navy on "rubberized equipment repair". I have made a few 8 X 10's but mostly 4 X 5's with graphic view and speed graphic.

About 3 weeks ago Clarence White Jr. of the Clarence White school of photography came down from Chicago, where the command of N.A.T.T.C. is located, to do a few special shots. He is a great admirer of your work and was amazed to find a son of "the"

Edward Weston working down here and as a metalsmith, not a photographer. I went around with him and his assistant, a first class photographer, to watch their special technique. He uses multiply flash with 3 extensions and that's about all. When he fled he took my service number rate, etc. and said he was seeing Steichen on his return, whether anything will come of it, I don't know, but I told him if they needed a good man in Chicago to let me know. He asked to be remembered to you and said some day he hopes to have the pleasure of meeting

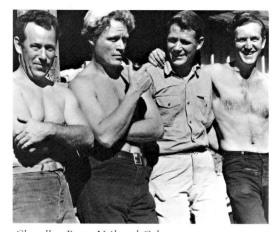

*Chandler, Brett, Neil and Cole*

you. He evidently doesn't follow in his old man's footsteps which I gather was soft focus etc.

By the way Pops, are you able to get any more Haliod than you use? I can't get hold of it out here and they won't take on new customers, so if you could get it for me, I will send you a money order. Grades 1, 2, 3, 1 gross each if possible. You are right about the rigors of photography in Oklahoma. It's just about impossible. Dirt and dust everywhere. The water is red from dust and your film after washing has a red slime all over them. It's impossible to keep the dust out of holders and magazines so dust specks are plentiful on negatives but we just plug on ahead doing the best we can. I have a refrigerator tank on my darkroom at the University, otherwise it would be impossible, even so developers and water climbs to 85 degrees and higher.

Does anybody know where Chan is now? or where we can write to him. I received a letter from Neil yesterday, he wants me to be his partner in another boat, 46 feet in length,

he says he can build it with my help in about 8 to 10 months and that he will have the necessary cash when he gets back. I am willing to help him on it but how will we live during the 10 months, I don't know. He wants to stay out in the Pacific longer in order to make the extra money needed. I would rather he come home and make it. I suppose he has written you all about it.

Well Pops, I have to dash off a letter to Neil then go over to the darkroom and print a sitting which I have already been paid for. Enclosed are a few more pictures of your mad son, note mustache is no longer with me, too hot and too much trouble.

Love to Charis and to my

Sweet Pops

Cole

P.S. "Battle of Norman" [cat] sends his best purr's to your 20 odd felines.

September 4, 1945

Dorothy and Cole

My sweet ones -

Long letters come, and only silence on my part! Starting with the Newhalls [Beaumont and Nancy - both photo-historians and friends], we have had a river of friends ascend upon us - Imogen Cunningham [photographer], Dr. Hertz, Ansel, Erica, a girl from Ohio University doing her M.A. on my life, loves and work. We added a chapter. Please don't misunderstand. Now Merle and Elsa [Armitage] are here! The grand climax. Of course the Jap surrender was terrific. But I just sat glued to the radio and wept. To go through a world war with 4 boys of draft age all intact was too much to take.

As to celebration, I don't think we can really celebrate until we have honestly won the most important part of the war, the peace.

All your photo exploits are of vast interest to the old man - but don't be hasty in buying what comes out of this war and make up your mind what you need. No one would be happier than Pops if you settled in Carmel. But I can't see it as a way to live and create for youth. I discouraged Brett who wanted to one time. But that's another time to discuss, on your furlough

*Oklahoma, 1945*                    *Cole Weston*

or discharge.   I think Truman is doing a pretty good job.  Back him for the time.  He needs you.  He kept Ickes.  He came out against Franco!

September 5, 1945

Dear Pops,

I guess you have been pretty busy as we haven't heard from you in some time except for a card, saying that you had received the photos and letters.

I don't know whether in my last letter I told of selling my 4 X 5 view, well after using an 8 X 10 here on the base, I have decided to get one of my own.  So far I have almost $400.00 saved up in my photo fund, it's amazing how it builds up.  I should be able to get myself a pretty good outfit by the time I leave here.  My only regret is that I won't have a camera to use when we drive across the country, unless of course, I buy it out here, which I won't do unless I get a good buy.  What would you advise as far as the make is concerned?  What do you think of the B&J 8 X 10? also what do you advise as far as lenses go, would you wait and get one of the newer coated ones?  I don't want to tear into it and then be sorry later on, so if you would give a beginner some advise I would appreciate it.

Over the Labor Day holiday, the first in 5 years, we went on a photographic expedition into the wilds of Oklahoma hinderland, the first time for me with an 8 X 10, to do what ever I had the urge to do.  Needless to say I was very excited.  I went out with great expectations as we had many hints from people, who were supposed to know, where the most exciting places were, Pre-historic canyons, strange formations, etc.  Well as you well know such hints rarely amount to anything, and they didn't after seeing California, one is spoiled.  Their huge canyons, were mere uninteresting gulleys, strange formations, where?  I don't know, but despite it all I think I got a couple of good ones of a church in the middle of a town.  I have learned from this experience to go in the opposite direction from where the so called nature lovers tell me to go.  I haven't developed yet as I just mixed up some A.B.C. Pyro today and didn't have time to use it.  It is the Carbonate that you put in at the last moment?  What film are you using now?

I wonder Dad, if you or Charis, would investigate as to what land, if any, is available for homesteading under the G.I. bill of rights, around Carmel or vicinity. If there is any and its not too distant from civilization, I might stake out a claim.

So far there isn't any more news as to my getting out, maybe 6, 8, 10 months, or a year for all I know.  I have a feeling that it won't be as long as most people think.  I will let you know as soon as I get any news.

Say, by the way, remember when we were discussing how long we thought Japan

would last after Germany we defeated, and I said I didn't think she would last more than 2 or 3 months, I wasn't far off was I. Well Pops, I have to hit the sack as it is getting late, so goodnight my sweet Papa, hope to see you very soon.

Much love

Cole

P.S. Battle of Norman sends his best to all of your kittens and hopes to meet them soon.

*Edward leaving for New York, 1946*

September 18, 1945

Cole Boy —

After talking with Ansel - he thinks nothing better on market than Ansco (Afga) 8 X 10; be sure it is late model with swing front and long bellows (36 inches at least). Ansel says "Commercial" model. If you can buy a 2nd hand do so, because Graflex Inc. is coming out with an 8 X 10 (perhaps) which is the last word, etc.

Ansel does not recommend coated lens for general use. However you can always get one coated after buying if you so decide. Lens buying is a problem. If you can find a Cook Triple convertible like mine or Ansel's - it's tops. In any event don't be hasty. For an 8 X 10, 3 focus lens, the doublet should be about 12 inches; Cook elements are 19 and 26 inch. In buying a convertible lens it is important to consider the quality of front and back combinations. Why not wait until you get back to the coast? Ansel says no on B&J 8 X 10 - I quote him because he is a dealer (one reason). I would write Veteran Administration about land in this vicinity for G.I.'s.

Love to you and dear wife

Pops

October 4/5, 1945

Dear Edward,

I know that Cole fully intends to write to you as soon as possible, so in the meantime I will type a short note to fill in until he has some time. Tonite he has duty again but I think he wants to write to Brett and also that stinker Chan. Have you ever heard anything from him? In the last letter we received from Brett he asked for our sleeping bag so that he

could take his time traveling across country after he gets a dependency discharge. However, we haven't heard any more so maybe it will be awhile before he does get a discharge. Even tho I wrote immediately to everyone we know explaining that Cole still has a two year hitch to do in the Navy we still get letters saying how wonderful it will be to be home by Xmas!!! We are keeping our fingers crossed these days as the schools here on the base are being transferred to either Corpus Christie or Pensacola (we think) and we are hoping to stay here for "the duration", now that we are settled and Cole has a damn good photographic clientele worked up. He has over 500 dollars in the bank now with prospects still bright and money still owed. I think the reason he was toying with the idea of an 8 X 10 is that he would like to have it to travel across country with when we leave here.

*Chandler, Dorothy and Cole in New York for Edward's show at MOMA, 1946*

We plan on staying in New Mexico with the Tants who are now living just outside Taos, we also want to stop over in Flagstaff, Arizona as the place intrigued us on our through on the train. It would be wonderful to have an 8 X 10 along.

Except for weather there is really no news here. Weather we have had a plenty including a ninety mile an hour gale with rain, thunder, and sheets of lightening. I really never realized before what wonderful weather we have on the west coast. No hurricanes, deluges, not days that look like the judgement day has come as at last, only earthquakes and I'll take those any day.

Well Edward, we will still be here when you fly to New York so you will have to stop by and see us either on the way there or back. Enclosed is fifty dollars which now squares us up. Thanks so for lending it to us when we were in such a pinch for we could never have made our last leave without it.

Write soon - Hi Charis, how about a letter from you too

All love

Dorothy

P.S. Hello Pops, just out of the salt mine for a couple of minutes to say Hi! I see that

Dorothy has neglected to tell you of my promotion. I am now AM 2/C which is equivalent to Staff Sargent in the Army. I'll be an Admiral before long.

Lots of love

Cole

October 18, 1945

Darlings -

Your letter and check. Thanks for both. Please don't go to Pensa or some such awful place. "BB" just here. Said that surplus commodity Board will sell to discharged army - and I suppose navy - 1941 Chevrolets for 300 to 500, if can prove need a car in business. This may not interest you. I am weary having just shipped last of my retrospective in 6 packages. Reaction set in at once.

Chan phoned from Hawaii! True to form a conference call with Ted [Chandler's son] on triangle. He is well, and in Navy yard, Pearl Harbor. If you get an 8 X 10, try to get one with swing front (vertical at least). By the way, show opens Feb. 12th. If you get a letter out of Charis you are a miracle worker - she and Chan are a pair on writing. Hope to leave for L.A. soon - trying for plane reservation -

Love

Dad

Pops

Edward

October 22, 1945

Dear Pops,

With all the school photography out of the way, I at last have a breathing spell. And some time to catch up on my neglected correspondence. I am taking your good advise about buying equipment, I think I will wait until I get out to the Coast. Unless you hear of a good buy, or possibly Ansel will, if so I will send the necessary money immediately. I would like to have an 8 X 10 when we travel west, but if I can't get a good deal, I guess I will just have to wait.

One of the fellows in the lab just received "The Encyclopedia of Photography", I guess it is the same one that you wrote the articles for. I just glanced through a couple of the ten volumes and saw several of yours with accompanying articles, also some of Brett's, I think I will send away for the set, as service men get it less than half price.

I made some tests using your Pyro formula, but I am a little confused over the results. I will send on the negatives and data, maybe you can help clear me up. I used Tri-S-Pan film (Afga) 200 Weston rating. I used a G.E. meter with 250 rating, it called for an exposure of 1/25 at F.32 which I gave it, then on the one for Pyro I opened up to F.11. I developed the first one in Afga 47 for 8 minutes and the 2nd one in fresh Pyro 3, 1, 1, for 20 minutes. Why is one in Pyro so thin? Is it underdeveloped? Surely opening up 3 stops would be enough time increase, that would make the exposure 6 times more than the first one. Does Pyro always give such a heavy stain?

Dorothy just came in with your last letter. I am so glad that you are at last through with your show, I bet it was a let down after so much work. Are you going to be in New York for the opening? What is the trip to L.A. for ?? your side?? [Edward had a hernia]. I hope you are at last going to get it fixed up.

Well Pops, I guess it won't be too long before we will have a big gathering of the clan in front of your roaring fireplace. We must all get together and have a huge gab fest, each telling of his experiences. I can't get over how lucky the Weston family was, in this War. God, it makes my skin creep when you hear some of our damn senators already talking of war with Russia, something has to be done, but what to do, I don't know. From the way the points are going I should get out sometime in March or April.

Much love
Cole

Halloween
Dear Sweet Ones
Monte (I call him Del Monte) and I have become fast friends, I live in Neil's room [Edward was staying in the old family house in Glendale - Edward and Charis were getting a divorce] - and he is on the way now, to oust me I hope. Can't decide whether to have my gut sewed up, or seared over. Sewing has advantage of speed - arguments pro and con. I flew down in 2 hours, then walked from Victory Blvd. to Glendale! Have had a fine welcome from all. Excepting weather.

My show is shipped. And I'm in a let down. No camera - no darkroom - Wish you, or least one of my boys or girls were here, to chase around with. Max [Ted's mother] is living at 4166, but works. So does Ted. He drove us to beach Sunday. Does well.
Am showing group of photos as usual. The ones I have with are my own "rejects" from shows, which does not mean don't like them.

And how goes your photographing? And dancing? And your discharge? Hope you

are out before I return!  Guess not.  What a mess the world is in.  Seems hopeless.  Most of Congress should be fired (I almost add "upon").  Writing very difficult on account drag in right hand.  I'm sure it's psychic, and not to do with my gut.

Tonight to Ruth Maitland's [one of Edward's patrons].  Have seen Walter [Ruth's husband] and Lou - New York goes over big.  "My best" - according to Walter.
But enough

Yr ever love

Papa

E -

Pops

Dad

November 28, 1945

Blessings dear children for calling your Pops.  The sound of your voices was sweeter than music.  Neil and I leave from Dunes on Tuesday.  I may try to settle there.  Then we go on to Carmel.  I will remain for awhile to finish orders and pack?  Of course I have to find a place to land in or on.  Merle has offered me a building site near Santa Fe.  Tempting but too far from my children.

More when I know more.

Hal Mohr tells me that a lens with unlimited depth of focus will be on sale soon.

December 21, 1945

Sweet Children —

I can never begin to tell you how much it meant to me to hear your voices, over the phone, full of regrets, cheer, understanding.  These have been hectic days of getting settled in, of getting used to a new life.  It is not all pleasant I can assure you; two persons together eleven years have built bonds difficult to sever.  But the split is not as sudden as most friends seem to think.   The last 3 - 4 years have been going down hill, rapidly.  My future is indefinite. Charis and I have had no property talk.  Much will depend on the outcome already sketched, and fairly by Charis.

If possible I should like to be closer to you boys than I have been for the last years - "you boys" - is always inclusive, boys plus girls.  Only Cole seems the only Weston with stability in human relations (or is it Dorothy?)  I'm wondering!  It might work out to try a much closer situation if Cole had really decided on photography as a profession.  I could

147

turn over much of my work, most of it, to him.

Deep love, great abrazos, Xmas cheer!

Pops -

December 29, 1945

Dear Pops,

I am afraid I can't quite put into words how I feel about your suggestion, about all I can say is that I feel very flattered, and very excited about the idea of such a venture. I only hope that I can live up to your faith in me. I have been working steadily since we were last together, and feel that I have made a good deal of progress both in knowledge and seeing; it's amazing to me, how the more you work, the more you see to work with, the barns, trees, dilapidated houses, gullys, ruts and river beds which I once took more or less for granted, I won't say that I passed them up without noticing them, because that would be impossible considering my bring up, but now these have all become exciting subjects for me. I haven't been so busy with portraiture lately, as the weather is turning cold, and with no studio, it is rather difficult to ask a sitter to stand outside and freeze, so I have been working hard with our old 8 X 10 every spare minute. When you use the single elements in a triple convertible, do you put the element in back of the shutter? I vaguely remember you telling me this.

Getting back to your letter, I don't know how much you have thought about, or planned, as to my working with you, or if you just want to get my reactions to the idea "What about location, etc." would you rather wait until I get out before we discuss it? I guess I am just over anxious, and excited about it all, I want to get started right away. I will have over a thousand dollars in the bank when I get out, and clear of all debts, doctors, dentist, hospitals, etc. We can continue to rent our house in the canyon in order to pay it off, unless of course, we decide to live in L.A., then we will have it. I guess you have gathered by now that I am anxious to hear more from you, but if you would rather, we will wait until I am out before we discuss it any further. I should get out around the middle of February or the first of March. The Civil Service Officer here on the base called yesterday to ask if I would be interested in being a government Photographer for New Mexico, Colorado, and Wyoming area. $2,900 a year, I told him I would rather be my own boss at $290.00 a year.

Well Pops, write me soon and give me details if any, CAN'T WAIT.

All my love

Cole

January 14, 1946

Dear Pops,

Your good letter at hand, I too agree with you that it is too big a subject to be discussed via. letter. I am scheduled to start checking out the 11th of next month and should be through the 15th. Walt Stanchfield [a friend] will follow me out next week, as our cars are not in such good conditions, and driving will be rough this time of the year, we are going to wait and drive out in a two car caravan, so we will be able to help each other in and out of snow drifts. This will delay our departure a few days, but I think it is wiser to do it this way. I will give you a ring as soon as we get into L.A. We will probably spend a few days there in order to get the house straightened out, then we will come up. I have decided not to send you any of my 8 X 10 things, but will wait until I will be able to get the first hand criticism. I went out yesterday, the first clear day in weeks, made a couple of rather nice ones of school house and group of cows, but wore myself to a frazzle and missed to boot, on "Prize Bull and Master Portrait", you should have seen me trying to use the 8 X 10 as minacam. I decided it couldn't be done, so I rushed to the car and got out my trusty Graphflex and at 1/100 at F.16 I got a couple that he should like. By the way, this same fellow keeps begging me to stay here in Okie land and go into business. He pulled out a couple of thousand dollars in War bonds last night, and asked if it would be enough to start us out. He thinks with his connections in the oil and cattle industry and my photographic eye, we could make a million, after all when one of these boys will pay $51,000 dollars for one bull. His argument is that they will pay plenty to have their pictures taken with that "expensive piece of meat". I can't quite seem to get it through his head that I am not money mad and that there are certain things in this world that money can't buy. He assured me that if we have another depression and I find myself starving to death, that I can always come out to Okie land and work on his farm.

Well Pops, I will have about 40 8 X 10's to show you when I get out, and am I ever anxious to TALK. See you soon,

Much love

Cole

And me too Dorothy

February 8, 1946

Dear Cole:

Hi sailor. I hear tell you will soon be out of the Navy and plan to follow Edward to New York to be with him during his show. I just returned from Mexico and tried right

away to reach Edward, but found he had all ready left, so without any further waste of time here is what is on my mind.

First of all, besides visiting N.Y. and squandering all your hard earned money, what are your plans? I've been hearing from Sid James, our West Coast boss, that we are short on photographers out here. He asked me if I knew any young guy who we could start breaking in out here. Naturally I thought of you. I couldn't pin him down to just how definite it all was or what would be paid, but he did seem to like everything I could tell him about you. In the first place it is Wilson Hicks in N.Y. who does the hiring and usually wants to see a guy's work first. Sid is, however, willing to write Hicks immediately, and should you go to N.Y. soon and are interested in the possibility of working, you should go up and see Hicks. The fact that you all ready have a home here and a car is very much in your favor. I imagine if you call on Hicks in the Time and Life Bldg. he will remember you from our party on Mesa Road several years ago. I must say that after hear-

*Peter Stackpole and family, c 1940*
*Cole Weston*

ing of this my first impulse was to coax you back here immediately while the thing was hot. Sid doesn't want to commit himself to the extent that he changes your plans, but he does say that there would be work for you whether you came immediately or in a few weeks. The important thing is for you to let me know immediately whether or not you are going to N.Y. and if so how long will you be there? Better wire me and then Sid will write Hicks and you can go up and see him. If you decide to do this I'd suggest you take along many of your best shots with action and spontaneity of most important. Cole, I suggest that if this interests you, and you still go to N.Y., and you get a satisfactory reaction from Hicks, don't spend too much time there and blow all your money, because you'll need it for equipment.

Incidently I'd help you with equipment to get you started. Also I'd give you all necessary advice on stories you'd shoot. Perhaps a lot of the stuff you'd be shooting at first would be fairly dull and they would probably put you on some kind of retainer bases to start with, but that is how Florea, Kaufman, Trudeau, and others out here have gotten started.
Please think this over and either wire or phone me soonest so that Sid can get off a letter to Hicks.

Best wishes to you and Dorothy.

Good luck. Peter [Stackpole]

April 29, 1946

Dear Edward - Pops

I will start this letter while waiting for Cole to return from "Life" office where Pete is helping him make out his Carmel expense account. We had bad news that the lot right next to us was sold - right out from under our noses. We are so disgusted, what with the way the canyon is being built up and all we very seriously are considering coming up to Carmel to live. Friday we are going to have an appraiser look over the house and see how much we can get for it. Then a trip up to see you and also find out if Rowen Tree (sp??) is willing to sell, if so how much and how much cash she wants. Dorothy D. [renter] will be out of our house in 2 weeks and we will move in chiefly to do some work on the place, which it needs badly. Cole feels he would rather free lance, work with you and take our chances. We have nothing to hold us here except the "Life" and Cole doesn't want to tie himself down or become involved in office politics. From what he says the little house and acre of land sounds perfect and I can think of no where I'd rather live. The very thought of it makes me feel happy and carefree. What a life! We will tell you more as things develop. Now that is off my chest, how are you? Brett says you are doing well, good - keep it up. The 12 days [Edward had a hernia operation] will pass eventually. I remember it is a dreary business at best, to lie in bed in a hospital. So many friends are asking after you.
Seems I am spilling all the news before Cole has a chance to, so I will stop now, Edward dear. Here's a big kiss and hug from your daughter. See you soon. What wonderful dreams I am having about our Carmel life together.

xxxx Dorothy

Dear Popocito,

Just a note to let you know we are all thinking of you and hoping that you will be out soon. As you will note from Dorothy's letter, I have about decided to give up "Life", I just see playing petty politics again, besides I want to know a hell of a lot more about photography than it takes to be a Life photographer. "Shoot a 100 rolls and you are bound to get a couple of good ones" seems to be their philosophy. After looking at the ten prints of the sand dunes which you showed me, I decided that I knew nothing about photography and that it was about time that I learned if I was planning to continue calling myself a photographer. So Dorothy and I will be up soon to look the property situation over.

All love

xxxxxxxooxxxxxx   Cole

*Cole*                                                                                                    *Ted Weston*

# Afterword

As we grow older, all we have left is our memories. Now, at age 80, when I have aches and pains or I can't sleep at night, I start remembering.

Even though Edward wasn't a typical father, he was wonderful. I loved him very much and I loved him all the time. He always read to us, as we sat in his lap. He came back from Mexico because of us boys. I think it's because of his childhood. His father re-married after his first wife, Edward's mother died, so his older sister raised him.

I always wondered why I was born. My parents were not living together at the time. I guess they got together once for old times sake and I was born nine months later. I can never remember sitting down to a meal with both parents.

My first memories of my Dad are sailing a little red boat in his darkroom sink. I was probably three or four at the time. Dad didn't live with us. He lived in his studio and we would go visit him. Mom would send Chan and Brett to spy on him, but not me. I was too little.

When I was older, playing ball, Neil and I broke the windows in Dad's darkroom. He sent us out with some of his old 8 x 10 glass negatives and a bucket of lye. We cleaned the emulsion off by dipping them in the lye and then replaced the windows. Times were tough and we didn't have money to go to the store to buy glass. I look back on that now and know that we must have cleaned some great images. But I don't know if Dad would have kept them. His style of photography had changed. He wasn't making soft focus images any more.

My mother was very supportive of my father. In fact I don't remember anything she

ever said against him. After she retired and moved to Carmel, I asked her about Dad. She told me that even though she knew what would happen, she would have done it all over again, she loved him and never stopped. Even when he was in Mexico with his mistress, Tina Modotti — a gorgeous gal, and they were broke, my mother would send him a couple of hundred dollars. Poor gal. She was making three thousand a year as a teacher and raising three boys, Chan was in Mexico with Dad. I remember she would come home after teaching and get the hose and water the flowers for hours. We had vines growing all over the house. She watered and she would sing. I once said something about Mom's singing to our friend and neighbor Rose Krasnow. Rose said, "Oh yes, she sang because she was unhappy." I didn't know that when I was growing up.

Because I was the youngest I spent time alone with my mother in Glendale. Neil was in Carmel with Dad. Brett and Chan were together in Santa Maria fighting and trying to start a portrait business. Now Mom wasn't the greatest cook in the world, but she could fix a mean turkey. It was either Thanksgiving or Christmas when she cooked me a beautiful dinner and there I was, sitting all alone at the huge table with a big turkey right in front of me. Mom had gone to bed.

I'm sure we felt competition with Dad's mistresses to get his attention. We used to call Sonya [Noskowiak], who lived with us in Carmel, "Scrawny Bitch" even though she was a good cook and she took care of my father. We resented her and we resented Dad's second wife Charis too. Charis was young, she was the same age as Brett. At Charis's eightieth birthday, we were asked, instead of presents, to tell a story. I said that I can remember when I was fifteen or sixteen Charis took me to the couch, (now Dad was in the kitchen,) and taught me to French kiss.

We were poor. When Dad died, he only had $300 in the bank and he was selling his prints for $25. Now some of his original prints sell for over $100,000. When Dad was photographing vegetables, after he was finished, we would eat them. He used to tell us, "Don't eat the bananas (or whatever) until I can photograph them." Brett always said to Neil and me, "You know I ate Pepper #30." And I would say, "Oh come on, Brett. How do you know you ate it?" He would say, "Well, it makes a hell of a story anyway, doesn't it?" And it does. It always brings down the house because Pepper #30 is Dad's famous pepper. We were rich in the things that really matter — love, life experiences and great stories.

After I went to work as Dad's assistant we would sit in front of the fire at Wildcat Hill and Dad would talk on and on. There were so many stories and things that happened and I wish I had tape recorded them. He was really concerned that Chan had this bad attitude. Chan was the last person with him when he died in 1958 on New Year's Day. Chan

got up in the morning and Dad came out and sat in his wheelchair and died. Ironic, isn't it?

As you can see, these letters have brought back a lot of memories for me — some good, some bad, but that's the way life is.

— Cole Weston
Garrapata Canyon
July, 1999

*Cole and Dorothy, Garrapata Canyon, 1948*

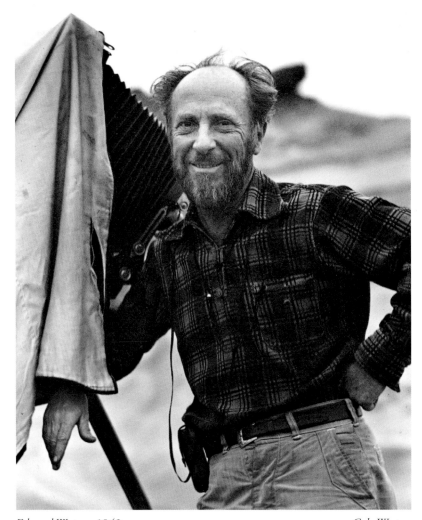

*Edward Weston, 1942*                                                    *Cole Weston*

# Afterword

I would like to be able to instill in the minds of each boy a profound concern with life itself - with beauty - joy - adventure - comradeship and creation.

The trouble with our whole sad - drab - hectic mess we so proudly boast of as "civilization" - is in the fact that we are almost totally concerned with the means toward life rather than life itself —

We are indeed a sorrowful lot to be scorned by the veriest savage.

How ironical that we waste our lives in feverish haste and fitful sleep to acquire comforts! We sweat and groan that we may buy tickets to have some other person dance for us when we should dance - or sing when we should sing.

We stiffen behind counters or cramp on a ledge-stool for the price of a book to learn how others live. We acquire dyspepsia or ptomaine poisoning for the privilege of buying canned abominations - a short cut to cooking.

Automobiles are ours and along with them obesity and tuberculosis. Blue-coated criminals with clubs and guns we hire to knock our heads and pick our pockets if we don't mind laws formulated by grey-haired-disintegrating old fossils whom we also hire to think for us.

If our neighbor steps out of the beaten path in some amorous adventure we look askance - but when the bill-boards read "Tonight - Rudolph Valentino - the World's Greatest Lover" - then the box-office is stormed by the secretly desirous ones - expecting some vicarious thrill

We are a lost and degenerate race living by the clock and thermometery - No - Not Living - Only Existing - working and resting so that we may work again - For What?

— Edward Weston

# Acknowledgments

I would like to thank:

Cole Weston for putting up with all the tears, time and headaches during the months spent working on the computer.

The Arizona Board of Regents, Center for Creative Photography, Tucson, Arizona for sending me the earliest letters between Cole and Edward.

Bob and Sharon Kolbrener, dear friends, who were reading "Laughing Eyes" when the publisher first saw it and who lovingly copied the images in the book from irreplaceable Weston prints.

Barbara March, my publisher, editor and friend.

Ray March, for his support.

Sally Aberg, for her thorough and objective proofreading.

Edward Bernstein, my friend and lawyer and his beautiful wife Sandra, who always include us in their family gatherings.

My grandson, Andrew Futato, who talks to me every Sunday and makes me laugh.

— Paulette Weston